the Lover's companion

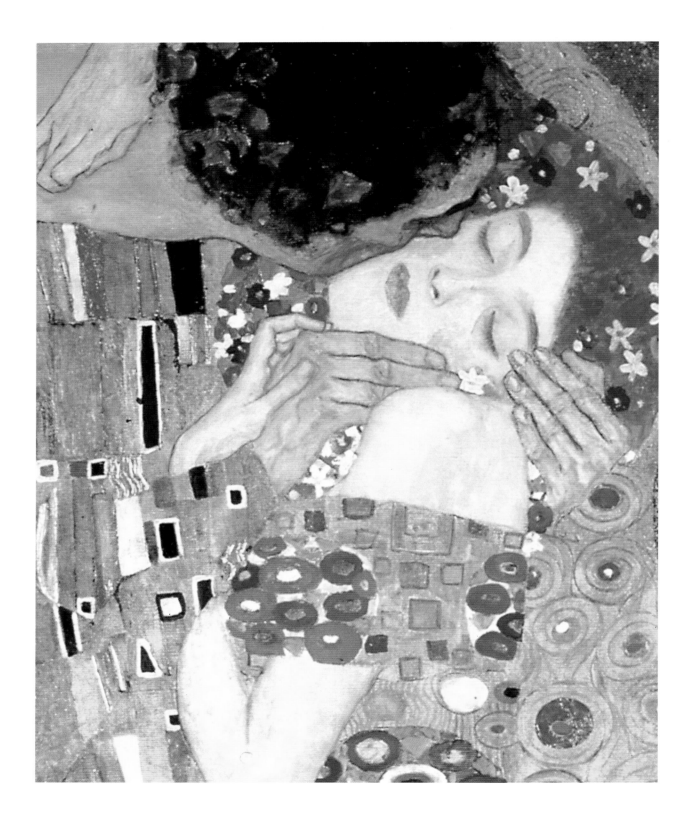

the Lover's companion *Art and Poetry of Desire*

Edited by **CHARLES SULLIVAN**

Commentaries by **DR. RUTH K. WESTHEIMER**

HARRY N. ABRAMS, INC., PUBLISHERS

THIS BOOK IS DEDICATED TO OUR RESPECTIVE FAMILIES.

The authors wish to acknowledge Mark Magowan, former Publisher of Harry N. Abrams, Inc., for suggesting the collaboration that has resulted in this book. Eric Himmel, his successor, has brought the project smoothly to fruition, with help from other able people at Abrams, among them Christopher Sweet. Finally, our warmest thanks to Pierre Lehu, a veritable "minister of communications" for Dr. Ruth and a good friend to us both.

DESIGNER: Brankica Kovrlija
ART RESEARCH AND PERMISSIONS: Fay Torres Yap, Carousel Research
TEXT PERMISSIONS: Peter Tomlinson and Laurie Winfrey, Carousel Research

LIBRARY OF CONGRESS CATALOGING-IN-PUBLICATION DATA
The lover's companion : art and poetry of desire / edited by Charles
Sullivan ; commentaries by Dr. Ruth K. Westheimer.
 p. cm.
Includes index.
 ISBN 0-8109-3491-4
 1. Love in art. 2. Senses and sensation in art. 3. Arts,
Modern—20th century. I. Sullivan, Charles, 1933- II. Westheimer, Ruth
K. (Ruth Karola), 1928-
 NX650.L68 L645 2002
 700'.4543—dc21

 2002009130

Printed and bound in Hong Kong
10 9 8 7 6 5 4 3 2 1

Harry N. Abrams, Inc.
100 Fifth Avenue
New York, N.Y. 10011
www.abramsbooks.com

Abrams is a subsidiary of

contents

introduction

THIS BOOK IS the result of a happy collaboration between Dr. Ruth Westheimer, known to millions for her wit and wisdom about human relationships, and Charles Sullivan, whose expertise in poetry and art has brought enjoyment to many readers. The collaboration is an especially happy one because Charles, who has a doctorate in psychology, shares many of the views expressed by Ruth in her various writings. Thus the collaborators have found it easy to agree on the selections of art and poetry—many of them classics—which are included in the book, and on their psychological significance for women and men of today. We hope that our readers will find Dr. Ruth's commentaries both amusing and insightful.

While, ideally, couples should not need any assistance when it comes to keeping the flame of love shining brightly, in the real world sometimes some added spark is required, at least occasionally. The authors hope this book can provide those sparks so that as two lovers enjoy sharing the art, the poetry, and the commentaries, their own relationship might become more artistic, more poetic, and we hope more erotic. There may also be times, however, when the book helps a solitary lover to understand or appreciate better some subtle aspect of a loved one or a relationship, whether ongoing or ended. And sometimes there is joy in anticipating pleasures yet to be experienced.

Lovers come in all shapes and sizes, as do the books meant for their enjoyment. Ours is far from being encyclopedic in coverage, yet it provides a colorful overview of the main features of loving relationships, plus some interesting sidelights here and there. So those who wish to enhance their love life with the beauties and ironies of poetry and art, plus the comfort of human understanding, should read on.

Because of Dr. Ruth's background, coming from an Orthodox Jewish family in Germany that was wiped out by the Nazis, she has made a point of honoring her Jewish tradition by placing a quote from some religious text in each of her books. For this book she has chosen a verse from the Song of Solomon:

> My beloved is like a roe or a young hart:
>> behold, he standeth behind our wall,
>> he looketh forth at the windows,
>> shewing himself through the lattice.
>>> (KJV 2:9)

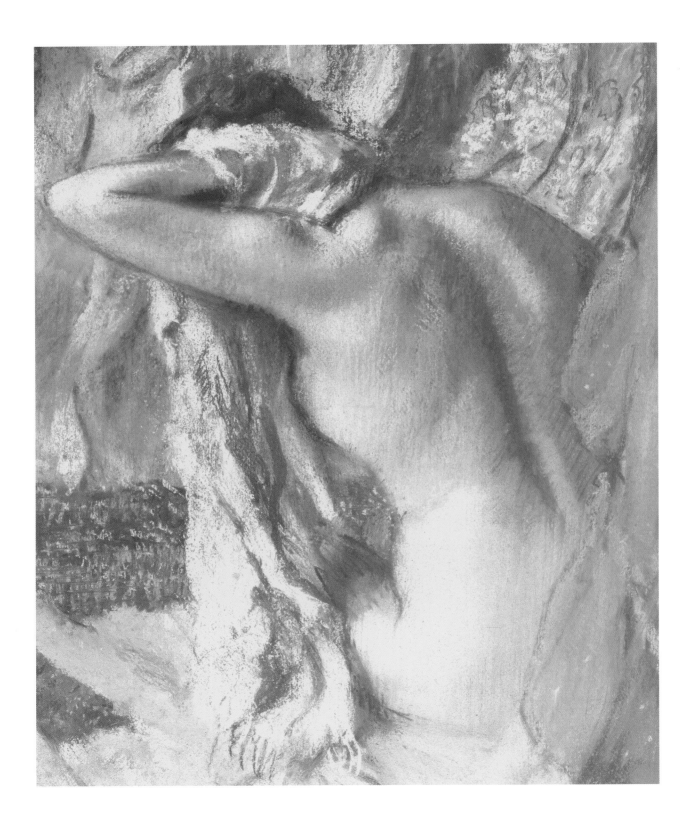

awareness

AN EXPERIENCED LADY'S MAN was once asked, "What Is the sine qua non of any new relationship?" "Availability," he answered promptly. But the question continued to interest him, and after a lot of further thought he came up with a different answer. "Awareness," he told the lady who had asked him. "I have been thinking about you for weeks." By then, unfortunately, she was no longer available. Yet their mutual awareness lingered on. So what is the moral of their story? Becoming aware of someone else is only the first stage in building a relationship with them.

Guillaume Apollinaire (1880–1918)

ANNIE

Translated from the French by William Meredith

Between Mobile and Galveston
On the seacoast of Texas
There's a big garden full of rosebushes
And a house like a big rose

Often there is a woman
Walking alone in the garden
And when I pass along the lime-bordered highway
We look at one another

She is a Mennonite this woman
And her rosebushes and clothes are buttonless
I see that two buttons are missing from my jacket
The lady and I observe almost the same rite

CLOTHING REPRESENTS a form of communication.
How many buttons are buttoned, or left unbut-
toned, sends a message. Showing a lot of cleavage
is an even clearer sign of intent. And I have read
that some women even purchase artificial nipples
to insert under their clothes to make it seem as if
their nipples are erect, which takes the process
one step further, though not quite as far as the
woman in the painting.

Difficulties arise when someone is dressing to
communicate to one person, but the rest of the
world is also getting the message. It is one of the
risks you take, and yet it also may be part of the
pleasure. After all, if no one notices you walking
down the street, then what kind of impression are
you going to make on your intended target? So,
as the saying goes: if you've got it, flaunt it. And
appreciate the reaction rather than reject it.

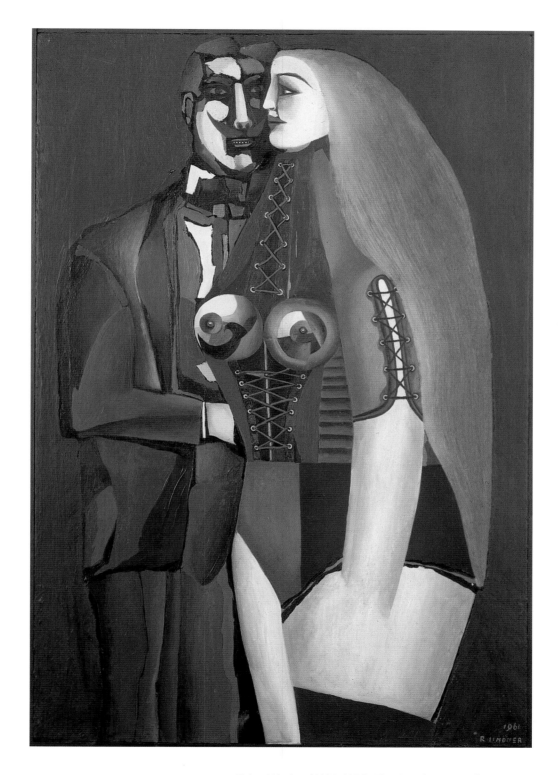

Richard Lindner (1901–1978). **The Couple.** 1961. Oil on canvas.

11

Marc Chagall (1887–1985). **The Birthday (l'Anniversaire)**. 1915. Oil on cardboard.

Jean Nordhaus (b. 1939)
ROOFER

He is fire and brimstone. Infernal
acrobat. You know the footstep
overhead, hot wind, acrid

smell of pitch. Gazing
into his fierce, angelic face,
as into a black sun

wreathed in flame, you suffer
vertigo and standing safe below
it is you who fall.

All day he feathers your house
with his argument. At night he soaps
with purest lye but cannot wash clean.

His wife makes a fold for him
among the sheets. He slides in
like a warm coal.

They sleep in the cellar
dreaming of perilous footholds
and the possibility of flight.

FANTASIES CAN BE WONDERFUL, and they can
also be very dangerous. The wonderful
ones give you a lift. They heighten your
libido and whether or not your partner is
the object of your fantasized desire, a sexy
fantasy can enliven your sex life in ways
that both partners benefit.

Where fantasies can be dangerous is if
they are revealed. You may find it arousing
to think of making love to an entire foot-
ball team, or their cheerleaders, or both
together, but your partner may find it quite
off-putting. A revealed fantasy can actually
endanger a relationship, in some cases, as
much as would an actual affair.

And then there are the fantasizers who
believe that their fantasies should, or even
must, come true. One woman I know asked
me to set her up with a famous comedian
who was the center of her fantasies. This
man, who had a partner and could have
had his choice among the most beautiful
women in the world, was never going to
consider entering her fantasy world. But by
clinging to the hope, she was ruining her
chances of ever finding a real partner.

So I have two pieces of advice regarding
fantasy. The first is to keep your mouth
shut about them. A secret fantasy is much
less dangerous than one that is revealed.
And the second is to vary your fantasies.
Don't get hung up on one particular fan-
tasy, or one person about whom you fanta-
size. You have my absolute permission to
fantasize all you want as long as you don't
get stuck in a rut. Use your creative juices
to make up a personal library from which
you can pick and choose.

D. H. Lawrence (1885-1930)
GLOIRE DE DIJON

When she rises in the morning
I linger to watch her:
She spreads her bath-cloth underneath the window
And the sunbeams catch her
Glistening white on the shoulders,
While down her sides the mellow
Golden shadow glows as
She stoops to the sponge, and her swung breasts
Sway like full-blown yellow
Gloire de Dijon roses.

She drips herself with water, and her shoulders
Glisten as silver, they crumple up
Like wet and falling roses, and I listen
For the sluicing of their rain-dishevelled petals.
In the window full of sunlight
Concentrates her golden shadow
Fold on fold, until it glows as
Mellow as the glory roses.

IF WE GO BACK to biblical times, with David and Bathsheba, or to Chinese tradition and the story of Yang Guifei and the emperor, we can see that men have long enjoyed watching a woman bathe, and in particular if it appears that she does not know she is being watched (or at least pretends not to know). The theme of the toilette appears throughout the history of art. Degas dedicated a series of pastels to depicting women bathing, standing in tubs, drying themselves, and brushing their hair. In each of them he places the viewer in the position of voyeur: the woman's face is turned away as she silently attends to the rituals of her toilette, seemingly oblivious to company. The poses of these women also mimic the stretches of Degas's dancers—a bather bends down to sponge her leg in the same manner that a ballerina leans over to tie her toe shoe.

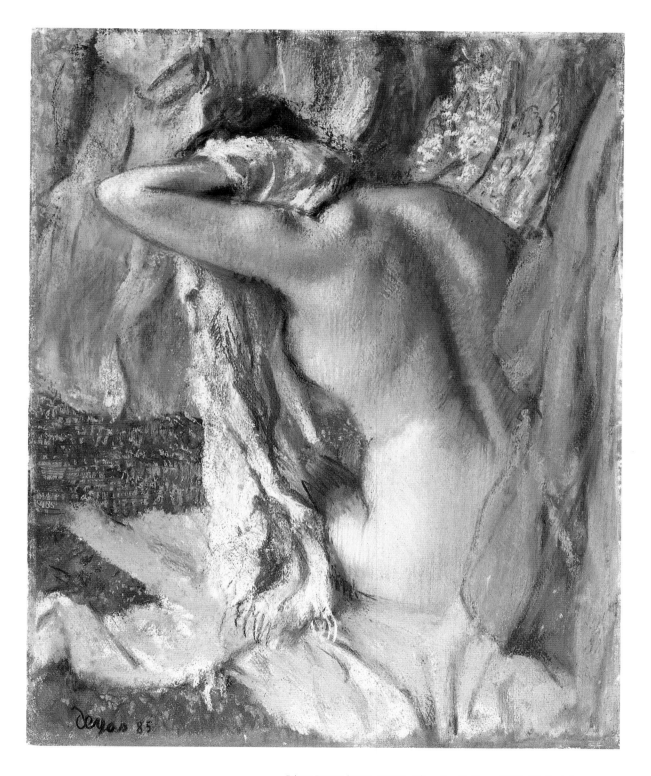

Edgar Degas (1834–1917). **After the Bath.** c. 1890–93. Pastel on paper.

WE ROSE UP SLOWLY ...AS IF WE DIDN'T BELONG TO THE OUTSIDE WORLD ANY LONGER ...LIKE SWIMMERS IN A SHADOWY DREAM ... WHO DIDN'T NEED TO BREATHE...

Roy Lichtenstein (1923–1997). **We Rose Up Slowly.** 1964. Oil and magna on canvas.

WAS THERE EVER a person more willing to be trapped than someone who has fallen in love? No matter how many times our hearts may have been broken, no matter how dangerous those shoals of love may be, we never seem to be able to stop ourselves from diving right in when the opportunity presents itself. If you always hold yourself back, then you'll never experience what love has to offer.

John Donne (1572–1631)

THE BAITE

Come live with mee, and bee my love,
And wee will some new pleasures prove
Of golden sands, and cristall brookes,
With silken lines, and silver hookes.

There will the river whispering runne
Warm'd by thy eyes, more than the Sunne.
And there th'inamor'd fish will stay,
Begging themselves they may betray.

When thou wilt swimme in that live bath,
Each fish, which every channell hath,
Will amorously to thee swimme,
Gladder to catch thee, than thou him.

If thou, to be so seene, beest loath,
By Sunne, or Moone, thou darknest both,
And if my selfe have leave to see,
I need not their light, having thee.

Let others freeze with angling reeds,
And cut their legges, with shells and weeds,
Or treacherously poore fish beset,
With strangling snare, or windowie net:

Let coarse bold hands, from slimy nest
The bedded fish in banks out-wrest,
Or curious traitors, sleavesilke flies
Bewitch poore fishes wand'ring eyes.

For thee, thou needst no such deceit,
For thou thy selfe art thine owne baite;
That fish, that is not catch'd thereby,
Alas, is wiser farre than I.

Barbara Angell (1930–1990)
THINK ABOUT

All those people you don't even know,
everybody, each one
a center of the universe,
all those skins.

Walking through a city at night
you see a light in a window,
a curtain flutters, a couple
making love, thinking
we're the first in the world,

or someone looking out on the street
humming a tune maybe, saying
I'm alone, the constellations
going around me,
I'm alone.

THE ART OF TITILLATION has all but disappeared. Before the so-called sexual revolution, a glimpse of bare skin, be it through an open window or across the room, could be quite a strong turn-on. Now that X-rated videos can be brought home to watch on 60-inch screens, and all manner of pornography is available to be downloaded onto any computer connected to the Internet, the thrill that comes from a peek at nudity doesn't carry the same power that it once did. Now I'm not against erotica, and I'm certainly not for censorship, but I do think we're a little poorer for the loss of titillation. There's too much rushing around in the twenty-first century, and that goes for hopping into bed on the first or second date too. Sex is something that needs to be savored, not gulped. People who don't take their time miss the nuances, and it's those nuances that really distinguish one sexual relationship from another. Even the most explosive orgasm disappears from your memory banks almost as soon as it is over, while the misty mood of a first kiss may linger forever. So while the sexual satisfaction that comes from an orgasm may remain an important goal, my advice is not to knock down every obstacle that stands in your way like a bruising running back, but instead to circle each other like two dancers and absorb every sensation created by the miracle of human sexuality.

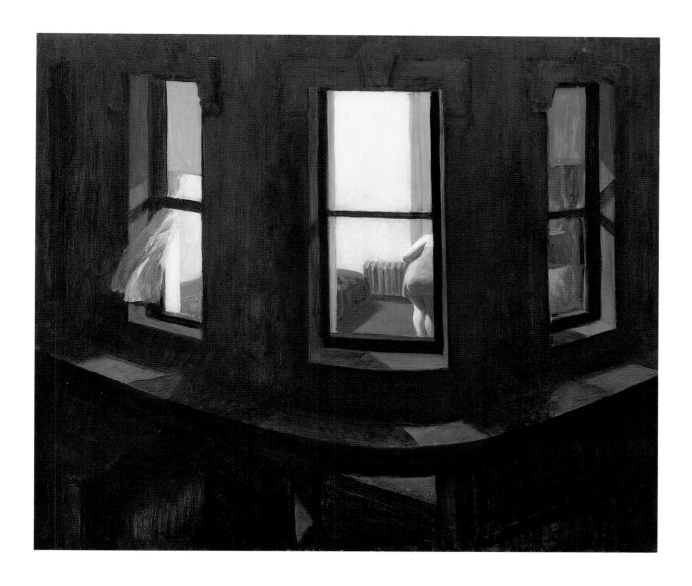

Edward Hopper (1882–1967). **Night Window.** 1928. Oil on canvas.

Marcel Broodthaers (1924–1976). **Watchtower.** 1966. Glass, wood, and magazine reproductions.

SONG TO CELIA

Come, my Celia, let us prove,
While we may, the sports of love;
Time will not be ours forever:
He at length our good will sever.
Spend not then his gifts in vain:
Suns that set, may rise again;
But if once we lose this light,
'Tis with us perpetual night.
Why should we defer our joys?
Fame and rumour are but toys.
Cannot we delude the eyes
Of a few poor household spies?
Or his easier ears beguile,
Thus removèd by our wile?
'Tis no sin love's fruits to steal,
But the sweet theft to reveal:
To be taken, to be seen,
These have crimes accounted been.

WHILE PEEPING TOMS are thought to catch people unaware, that's not always the case. Many people, both men and women, get a thrill by allowing to be seen that which is not supposed to be seen. If you want to protect yourself from prying eyes, even a sheet thumb-tacked across a window will do nicely. But many people don't always take even minimum precautions, and while they may act shocked to find someone looking in at them, they actually wanted to be seen.

Charles Sullivan (b. 1933)
AWARENESS

I never think of you
naked, or in bed with me,
or making love, I see
only what you've let me see—
your pretty clothes, the way
you sit in someone else's house,
your swelling blouse, your smile,
your eyes, your trembling hand,
and then your questions coming at me
through your words, like birds
whose cage I might spring open—
that's how it begins—I can't say
you're always with me, love,
at my age, but I think of you
each day I live as a present
yet to be given.

THESE DAYS too many young people rush into having sex. They think that after a date or two if they haven't hopped into bed then something is wrong. It can be hard to convince them otherwise. Since the risk of pregnancy can be avoided, what's to stop them they ask? Isn't more sex better than less sex?

While I can't say that once the relationship has entered a sexual phase less sex is better than more sex, there are pleasures to be derived from the anticipation of sex that evaporate the moment the deed is done. Think of the excitement kids feel on the days leading up to Christmas morning. Would receiving those gifts be as much fun if they simply woke up on some unexpected day and found a pile of presents at the foot of their bed? Even the time it takes to unwrap them adds to the delight of the experience.

I have to admit that patience is not one of my virtues, so I understand their dilemma. But the point is that by slowly building a relationship and savoring each new step toward intimacy, you increase the overall enjoyment of the experience. These are moments that can never be recaptured. Once you start having sex, you can do it over and over again but even if you want to relive the days you were courting, even if you go so far as to pretend that the two of you have just met in a bar, it won't be the same. So my advice is to take it slow and think of that first time you are going to have sex as a present yet to be given.

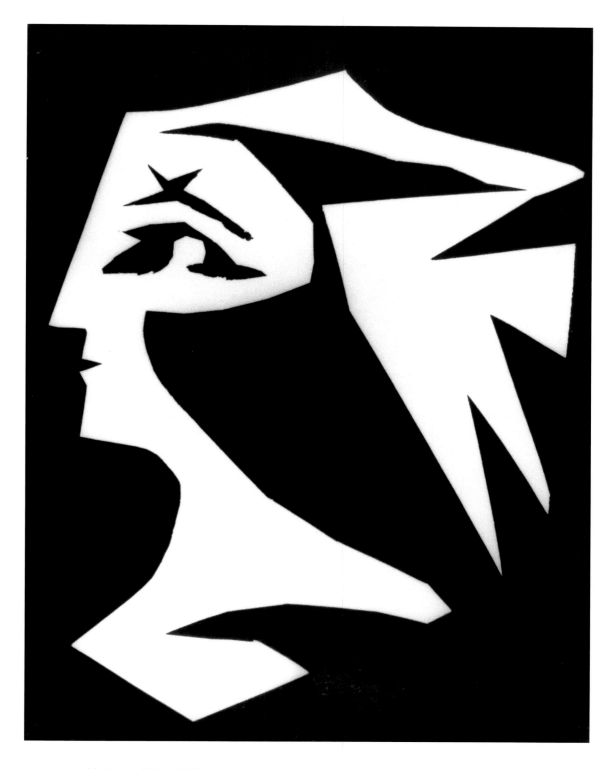

Pablo Picasso (1881–1973) and André Villers (b. 1930). **Head in Profile.** Undated. Photograph of a découpage.

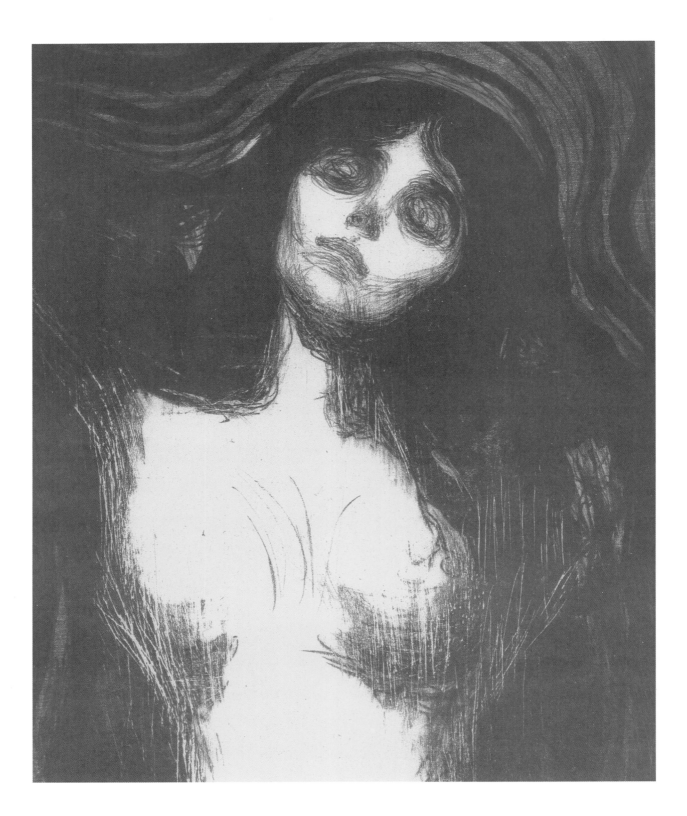

my body

ONE'S OWN BODY, one's needs and desires, are obviously starting points for taking an interest in some-one else. An intensely romantic interest may focus on the other person almost to the exclusion of one's self. But such a one-sided relationship may remain one-sided. More realistically, lovers should have a healthy interest in their own bodies, their own pleasure, as well as their partner's. Balance is the key here, as in many other aspects of love and lovemaking.

John Dryden (1631-1700)
SONG FOR A GIRL

Young I am, and yet unskill'd
How to make a lover yield;
How to keep, or how to gain,
When to love, and when to feign.

Take me, take me, some of you,
While I yet am young and true;
Ere I can my soul disguise,
Heave my breasts, and roll my eyes.

Stay not till I learn the way,
How to lie, and to betray:
He that has my first, is blest,
For I may deceive the rest.

Could I find a blooming youth,
Full of love, and full of truth,
Brisk, and of a jaunty mien,
I should long to be fifteen.

WHEN I WAS A TEENAGER, because I was very short, I was certain that I would never find anyone who would marry me. But I was experiencing a universal angst. As every young female changes from a girl to a woman, as she develops breasts and hips, she notices that men start to look at her in a different manner. She soon realizes that she has a certain power that she can wield over men that she didn't have before. She dreams about using that power and about really experiencing those warm feelings of lust that wash over her every once in a while.

In his painting, Balthus seems to be showing a young girl who has just exercised this power and is looking at herself in a new light. The man, who is lighting the fire and who figuratively has just lit her fire for the first time, is not important. What we are seeing here, one could say along with her, is the very process as she changes from a girl into a woman. She will never be the same, and while she will definitely enjoy her newfound powers (which may have even earned her that pearl necklace she is wearing) there will be times when she'll wistfully look back on her innocent girlhood. But like that ruptured hymen that can never be put back in place, she cannot return to being a child. Nor can we.

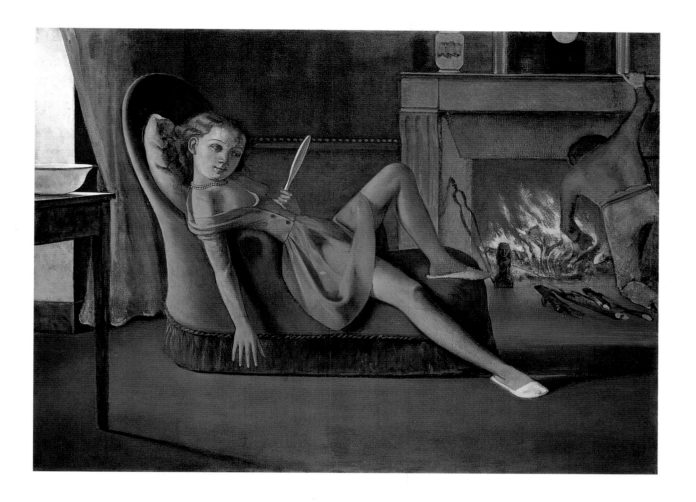

Balthus (1908–2001). **The Golden Days.** 1944–46. Oil on canvas.

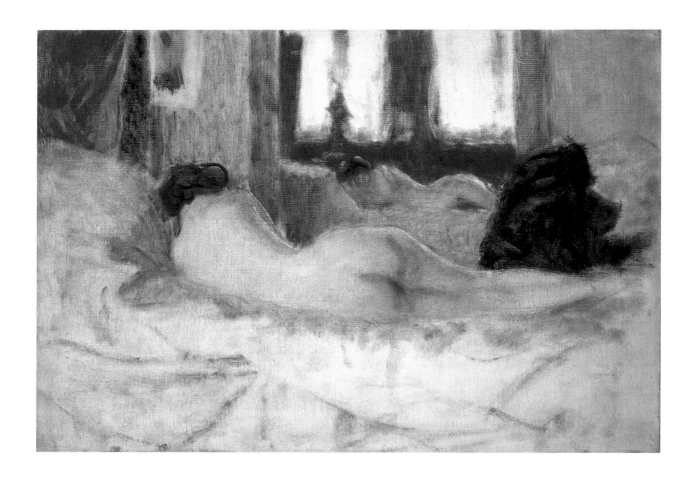

Roderic O'Conor (1860–1940). **Reclining Nude Before a Mirror.** 1909. Oil on canvas.

Eavan Boland (b. 1944)
THE WOMEN

This is the hour I love: the in-between
neither here-nor-there hour of evening.
The air is tea-colored in the garden.
The briar rose is spilled crêpe de Chine.

This is the time I do my work best,
going up the stairs in two minds,
in two worlds, carrying cloth or glass,
leaving something behind, bringing
something with me I should have left behind.

The hour of change, of metamorphosis,
of shape-shifting instabilities.
My time of sixth sense and second sight
when in the words I choose, the lines I write,
they rise like vapors and appear to me:

women of work, of leisure, of the night,
in stove-colored silks, in lace, in nothing,
with crewel needles, with books, with wide-open legs,

who fled the hot breath of the god pursuing,
who ran from the split hoof and the thick lips
and fell and grieved and healed into myth,

into me in the evening at my desk,
testing the water with a sweet quartet,
the physical force of a dissonance—

the fission of music into syllabic heat—
and getting sick of it and standing up
and going downstairs in the last brightness

into a landscape without emphasis,
light, linear, precisely planned,
a hemisphere of tiered, aired cotton,

a hot terrain of linen from the iron,
folded in and over, stacked high,
neatened flat, stoving heat and white.

EAVAN BOLAND SAYS she does her best
work in the early evening, and through
the night. I, too, am not a morning per-
son, so I know how she feels. And the
woman in the picture certainly looks like
what is labeled "a lady of the evening."
But others are like doves and wake up
before the sun has risen and are ready to
do their best work at dawn's first light.
People are born with different circadian
rhythms, and sometimes people with
opposing cycles do fall in love and even
get married.

In the early stage of this type of rela-
tionship, when the two parties' passions
override their birth-decreed timetables,
the conflicts may appear minimal. But
after their passions have gone through
the natural evolutionary cooling process,
such couples can go through some rough
spots.

The key to overcoming differences of
this sort is a willingness to compromise
and to schedule. One party may have to
take naps. Another may have to inter-
rupt after-dark creativity for some under-
the-covers fooling around and then hop
back out of bed. They may need to
weave alarm clocks into their personal
brand of foreplay. None of this is calami-
tous. What would be a tragedy was if
they allowed their different sleeping
habits to so interfere with their relation-
ship that it split them apart.

Howard Nemerov (1920–1991)
YOUNG WOMAN

Naked before the glass she said,
"I see my body as no man has,
Nor any shall unless I wed
And naked in a stranger's house
Stand timid beside his bed.
There is no pity in the flesh."

"Or else I shall grow old," she said,
"Alone, and change my likeliness
For a vile, slack shape, a head
Shriveled with thinking wickedness
Against the day I must be dead
And eaten by my crabbed wish."

"One or the other way," she said,
"How shall I know the difference,
When wrinkles come, to spinster or bride?
Whether to marry or burn is bless-
ed best, O stranger to my bed,
There is no pity in the flesh."

THE NORWEGIAN ARTIST Edvard Munch continually explored themes of despair and death. His dark subjects likely stem from his personal tragedies: his parents, a brother, and a sister all died when he was young. He struggled with anxiety, illness, and alcoholism, but he declared that art gave meaning to his life. His depiction of the Madonna, however, is surprisingly erotic. Her open, naked body and upturned face, with eyes closed, suggest ecstatic release. However, the edge of the lithograph is framed with spermatozoan shapes, which seem to be encircling the figure of the Virgin Mary, as a small, fetuslike figure crouches in the corner. Munch had many unhappy love affairs, and this picture reflects his fears that women are untouchable.

Edvard Munch (1863–1944). **Madonna.** 1895–1902. Lithograph and woodcut.

32 Robert Mapplethorpe (1946–1989). **Thomas 1987.** 1987. Gelatin-silver print.

Walt Whitman (1819–1892)
O MY BODY!
from I Sing the Body Electric

O my body! I dare not desert the likes of you in other men
 and women, nor the likes of the parts of you,
. .
Head, neck, hair, ears, drop and tympan of the ears,
Eyes, eye-fringes, iris of the eye, eyebrows, and the waking
or sleeping of the lids,
Mouth, tongue, lips, teeth, roof of the mouth, jaws, and
the jaw-hinges,
Nose, nostrils of the nose, and the partition,
Cheeks, temples, forehead, chin, throat, back of the neck,
neck-slue,
Strong shoulders, manly beard, scapula, hind-shoulders,
 and the ample side-round of the chest,
Upper-arm, armpit, elbow-socket, lower-arm, arm-sinews,
arm-bones,
Wrist and wrist-joints, hand, palm, knuckles, thumb,
 forefinger, finger-joints, finger-nails,
Broad breast-front, curling hair of the breast, breast-bone,
breast-side,
Ribs, hip-sockets, hip-strength, inward and outward round,
man-balls, man-root,
Strong set of thighs, well carrying the trunk above,
Leg-fibres, knee, knee-pan, upper-leg, under-leg,
Ankles, instep, foot-ball, toes, toe joints, the heel;
All attitudes, all the shapeliness, all the belongings of my
 or your body or of any one's body, male or female,
. .
Womanhood, and all that is a woman, and the man that
comes from woman,
The womb, the teats, nipples, breast-milk, tears, laughter,
 weeping, love-looks, love-perturbations and risings,
. .
The continual changes of the flex of the mouth, and
around the eyes,

The skin, the sunburnt shade, freckles, hair,
The curious sympathy one feels when feeling with the
hand the naked meat of the body,
The circling rivers the breath, and breathing it in and out,
The beauty of the waist, and thence of the hips, and
thence downward toward the knees,
. .
O I say these are not the parts and poems of the body only,
but of the soul,
O I say now these are the soul!

THERE HAVE BEEN, and continue to be, people
of various faiths, who give up the pleasures of
the body in order to devote themselves to the
soul. Now I would never say that they are
wrong. Who knows, perhaps it is God who
called them to do this. But it seems to me, for
mankind in general, that to disconnect any
part of the body, be it the lips for speaking or
the genitals for having sex, is not the path that
God has mapped out for us. We are not inex-
orably tempted into evil by the sexual nature
of our bodies. Yes, our sexual organs can be
used for evil purposes, but no more so than
our fingers or toes. There is a line that if
crossed can bring about our ruination, both
morally and physically, but this line is not so
close to the path that most of us tread that we
need be fearful of the regular sexual function-
ing of our bodies. Like Walt Whitman, we
should celebrate each and every part of our
bodies because they truly "are the soul!"

Anonymous (early 18th century)
SUSANNAH AND THE ELDERS

Susannah the fair
With her beauties all bare
Was bathing her, was bathing herself in an arbour;
The elders stood peeping and pleas'd
With the dipping,
Would fain have steered into her harbour.

But she in a rage
Swore she'd never engage
With monsters, with monsters, with monsters so old
and so feeble.

This caus'd a great rout
Which had ne'er come about
Had the elders been sprightly and able.

THIS VERSE IS A HUMOROUS ONE but in the original biblical story, because Susannah refused to have sex with the two elders who had been spying on her, they testified against her and she was to be put to death. Luckily for her, her prayers were answered and a young man, Daniel, was able to prove her innocence, and so it was the two elders who suffered the fate to which she had originally been condemned.

The two elders tried to use their power to force the girl to have sex with them. They may have failed, but our headlines continue to be filled with such stories, and I guess we shouldn't be surprised. Men desire sex, and of what use is power if it can't bring you what you desire—or at least that's what these men seem to think.

Power has been called the ultimate aphrodisiac (and I've even written a book on just that subject) and history is filled with stories proving it true. Of course beauty and wealth also share in this gift. But the lust that comes from power seems often to be associated with danger as well, and even death. Susannah would have died but for Daniel, and in the story of David and Bathsheba, it's Bathsheba's husband who was killed so that the king could have his way. So not only is power the ultimate aphrodisiac, but it's also the most dangerous one.

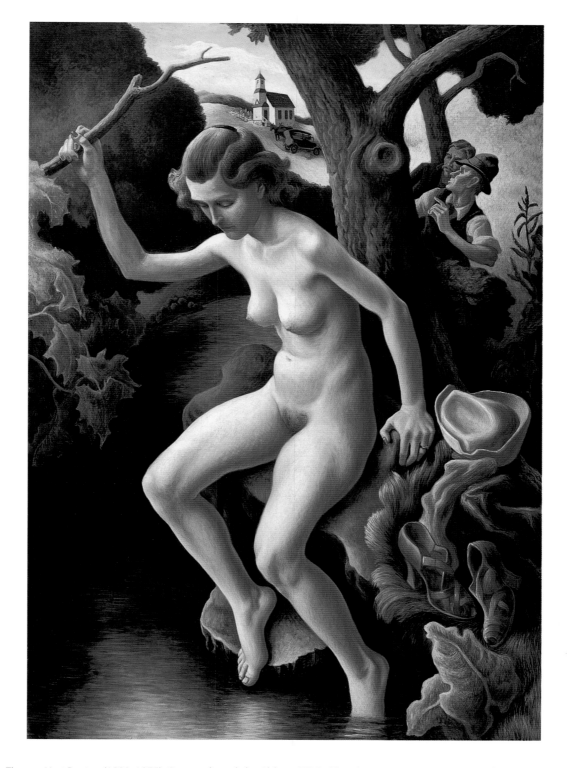

Thomas Hart Benton (1889–1975). **Susannah and the Elders.** 1938. Oil and tempera on canvas mounted on panel.

Roman (1st–3rd Century). **Faun with Staff of Aesculapius.** Fresco from Pompeii, Italy.

Robert Burns (1759-1796)
NINE INCH WILL PLEASE A LADY

Come rede me, dame, come tell me, dame,
 My dame, come tell me truly,
What length o' graith, when weel ca'd hame
 Will ser'e a woman duly?
The carlin clew her wanton tail,
 Her wanton tail sae ready;
I learnt a sang in Annandale,
 Nine inch will please a lady.

But for a countrie cunt like mine,
 In sooth we're nae sae gentle;
We'll take twa thumb-bread to the nine,
 And that's a sonsie pintle.
O leeze me on my Charlie lad!
 I'll ne'er forget my Charlie;
Twa roarin' handfu' and a daud,
 He nidg't it in fu' rarely.

But weary fa' the laithern doup,
 And may it ne'er ken thrivin';
It's no the length that gars me loup,
 But it's the double drivin'.
Come nidge me Tam, come nodge me Tam,
 Come nidge me o'er the nyvel;
Come loose and lug your batterin' ram,
 And thrash him at my gyvel.

rede = teach
graith = instrument
weel ca'd hame = well knocked home
carlin = old woman
sonsie = plump, thriving
leeze me on = I was pleased with
daud = a large piece
laithern doup = lazy, tired buttocks
gars me loup = makes me jump

ONE OF THE QUESTIONS that I am asked the most is about penis size, which is why I loved this poem by Robert Burns. It demonstrates that this is an age-old question, and the answer remains the same; it's not the size that matters but the skill of the lover. The truth is, most women cannot have an orgasm from intercourse alone and so for them to derive the complete benefits of a sexual episode, their partners must know how to put other, more dexterous parts of their anatomy—from their tongues to their fingers to their big toes—to good use.

In fact, I also get letters from men with a "nine inch nail" who have problems because women either are afraid of their equipment, or it causes them pain. So while there are some women who prefer a bigger penis; most women are not concerned with the size of a man's penis; but they do want a partner who is skilled at helping them achieve sexual satisfaction.

Robert Graves (1895–1985)
DOWN, WANTON, DOWN!

Down, wanton, down! Have you no shame
That at the whisper of Love's name,
Or Beauty's, presto! up you raise
Your angry head and stand at gaze?

Poor bombard-captain, sworn to reach
The ravelin and effect a breach—
Indifferent what you storm or why,
So be that in the breach you die!

Love may be blind, but Love at least
Knows what is man and what mere beast;
Or Beauty wayward, but requires
More delicacy from her squires.

Tell me, my witless, whose one boast
Could be your staunchness at the post,
When were you made a man of parts
To think fine and profess the arts?

Will many-gifted Beauty come
Bowing to your bald rule of thumb,
Or Love swear loyalty to your crown?
Be gone, have done! Down, wanton, down!

I OFTEN GET LETTERS from young men complaining that they get erections at the most embarrassing moments, such as when they are called to write on the blackboard at the front of the class. But as annoying as it may be to have an erection when you least want one, such a situation is far better than its opposite. As a man grows older, he loses the ability to have a psychogenic erection, an erection that comes from thinking an erotic thought or viewing a sexy image. The man then requires physical stimulation to achieve an erection. If both partners understand that this is a natural occurrence, it is easy to deal with the situation.

Christo (b. 1935) and Jeanne-Claude (b. 1935). **5,600 Cubic Meter Package.** 1967–68.

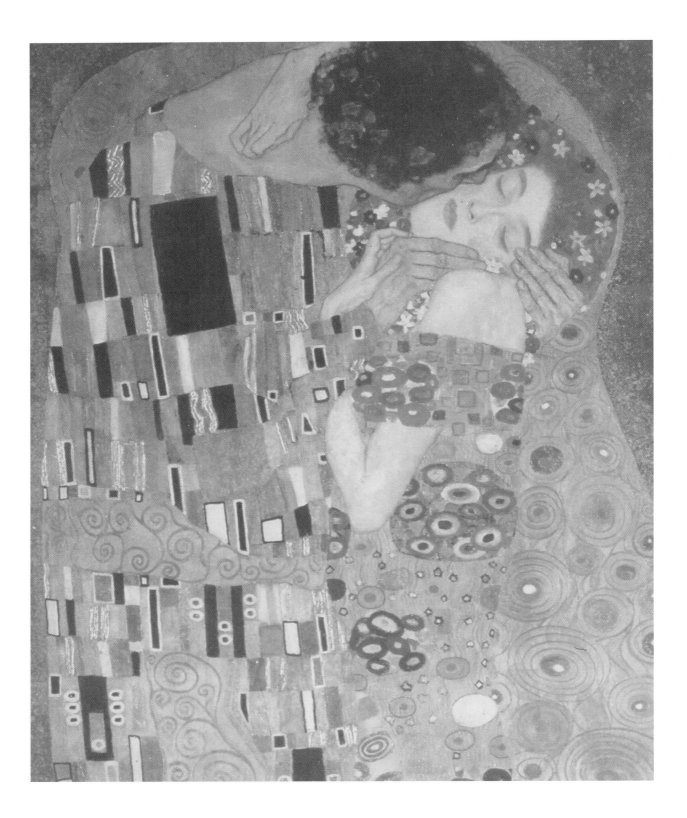

your body

THE BODY OF ONE'S LOVER may become increasingly attractive, as a whole and in some or all of its parts. Legs, breasts, buttocks are familiar examples, for women as well as for men. But attractiveness may extend to any part of the body, from head to toe, unclothed or clothed. Looking, touching, caressing, kissing—many are the ways for beauty to be saluted, whether it is only in the eye of the beholder or "objectively" present in the beloved.

E. E. Cummings (1894–1962)

I LIKE MY BODY WHEN IT IS WITH YOUR

i like my body when it is with your
body. It is so quite a new thing.
Muscles better and nerves more.
i like your body. i like what it does,
i like its hows. i like to feel the spine
of your body and its bones, and the trembling
-firm-smooth ness and which i will
again and again and again
kiss, i like kissing this and that of you,
i like, slowly stroking the, shocking fuzz
of your electric fur, and what-is-it comes
over parting flesh. . . . And eyes big love-crumbs,

and possibly i like the thrill

of under me you so quite new.

THE PHILOSOPHY PROPAGATED by this poem and assemblage, "I like my body," is a wonderful one. I love the smile on the man's face. He is happy with his body. If only everybody could share that joy. And I don't mean just those without partners. Many people, of both sexes but especially women, are too ashamed of their bodies to show them even to their mates. They'd probably be happier if our society still slept in nightgowns with holes built in for having sex. In most cases it's not the spouse's complaint or criticism that causes the shame, but rather an inner lack of self-esteem.

Though it's not a cure-all, for women who have this problem, I would suggest a visit to a museum of art. We've all been bombarded by the media with images of women who look like beanpoles. But when you wander through the galleries of paintings, from the earliest ones right through the Impressionists, you'll see that for centuries, thin was not in. An ample thigh, a lusty arm, a quivering belly were nothing to be ashamed of.

Such a visit will not completely solve a problem of poor self-esteem, but it may help. When your lover tells you he likes what he sees, instead of doubting him, use those images you saw in the museum to convince yourself that he is telling the truth. Fantasize that the two of you are bringing one of those paintings to life, and there's a chance that you'll be able to smile too when you take off your clothes.

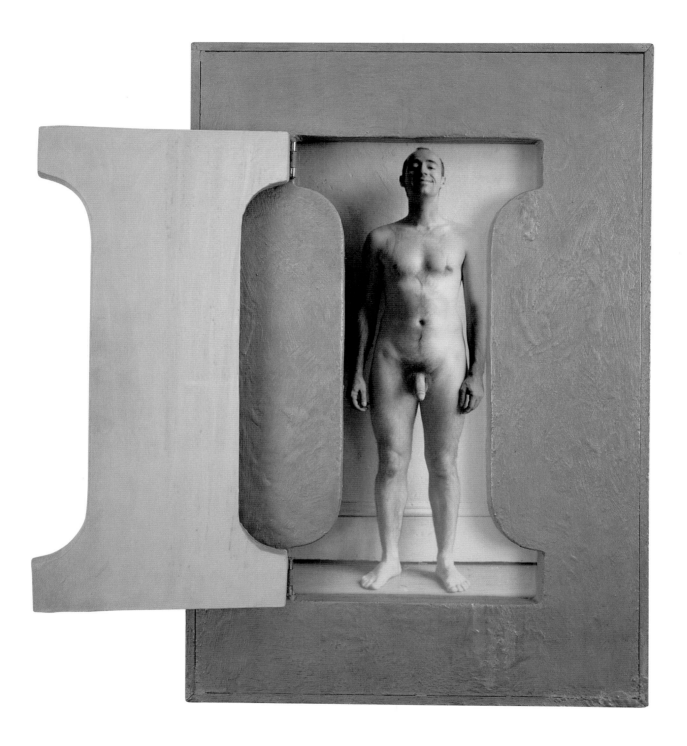

Robert Morris (b. 1931). **I-Box.** 1962. Mixed media. 43

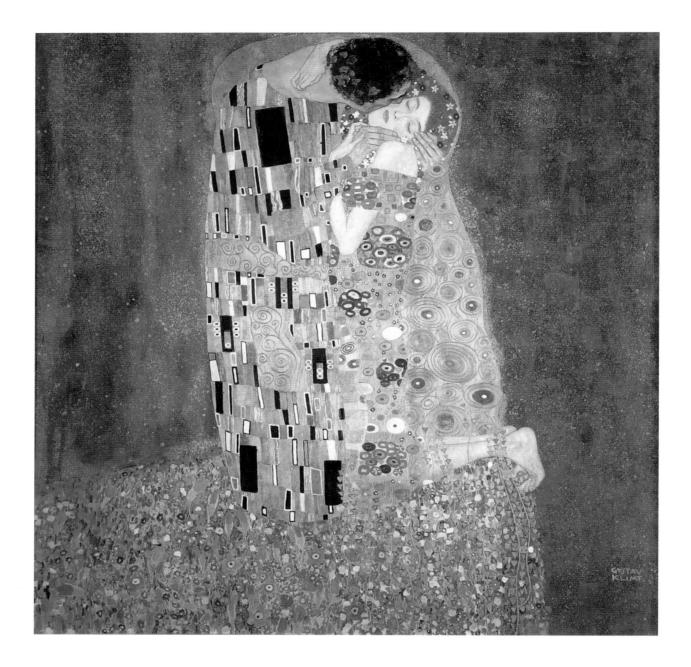

Gustav Klimt (1862–1918). **The Kiss.** 1907–08. Oil on canvas.

Robert Herrick (1591–1674)

CLOTHES DO BUT CHEAT AND COZEN US

Away with silks, away with lawn,
I'll have no scenes or curtains drawn;
Give me my mistress as she is,
Dress'd in her nak'd simplicities:
For as my heart, e'en so my eye
Is won with flesh, not drapery.

HERRICK WANTS HIS LOVERS "nak'd" while Klimt prefers sumptuous gowns. Certainly some people look better naked than clothed, but clothes can also camouflage the body in ways that make it look more appealing.

In most societies, we have no choice but to wear clothes because for much of the year we require their protection, from the sun as well as the cold. And once our primitive ancestors left the jungle and started covering up, it's not surprising that the societies that then developed would have integrated the custom in some formalized manner. But I find it sad that the Western world brought shame to those parts of the world where nudity was still the norm. To me, it's not a sign of progress that such peoples now cover up, but one of having spoiled what was natural. Just as I believe that the story of Eve bringing the concept of shame to mankind has ill-served half of the human race, Western interference with other peoples' cultures does not better them. If there are people who don't like to see naked humans, they should just stay out of these peoples' territories.

I may not be in favor of bucking thousands of years of tradition and making ours a clothing-optional society, but I also don't feel that the naked human form is shocking in any way. Maybe if we did spend more time being naked around each other our societies would have less sexual hang-ups, fewer concealed weapons, and a better sex life, too.

Robert Herrick (1591–1674)

UPON THE NIPPLES OF JULIA'S BREAST

Have ye beheld (with much delight)
A red rose peeping through a white?
Or else a cherry (double grac'd)
Within a lily? Centre plac'd?
Or ever mark'd the pretty beam,
A strawberry shows, half drown'd in cream?
Or seen rich rubies blushing through
A pure smooth pearl, and orient too?
So like to this, nay all the rest,
Is each neat niplet of her breast.

BACK IN THE DAYS when women covered almost every square inch of their skin, all it took was a glimpse of ankle to drive men wild. Today no one notices a bare ankle, but a little cleavage can cause great excitement—so how wonderful is it to look at the enormous, full breast in Tom Wesselmann's painting? One of the first Pop artists, Wesselmann is interested in advertising and collage, as seen in this stylized "still life" of a breast, a telephone, and an orange.

Let us hope that we never become so blasé about breasts and nipples that we ignore them. When they're firm and round they have an inherently sensuous quality, even to other women. People with busy lives filled with work and responsibility need triggers to their libidos. We need more lovemaking, not less, and breasts deserve to be adorned with flowers, pinned with medals, pushed upward and outward by bras, and yes, even ogled.

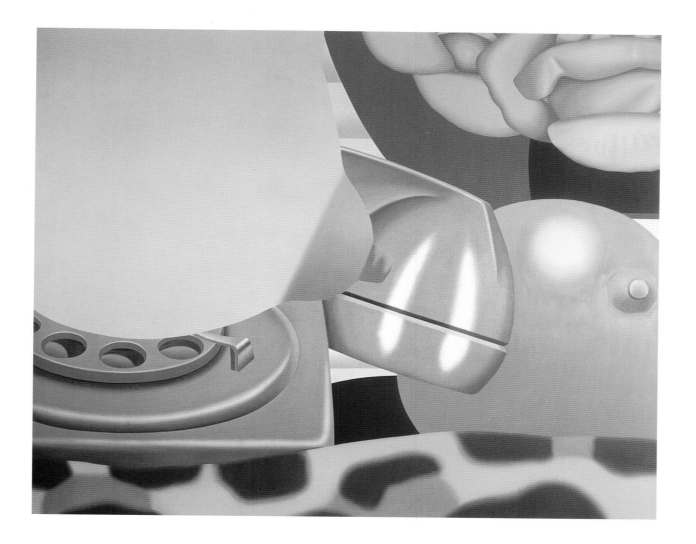

Tom Wesselmann (b. 1931). **Bedroom Painting No. 25.** 1967–71. Oil on canvas. 47

9.10.64.
III

Pablo Picasso (1881–1973). **Couple.** 1964. Colored pencil on paper.

Grace Cavalieri (b. 1932)
FEELING STATES

The penis is an appendage
Which listens.
No mind of its own
It moves when beckoned,
The spirit goes as far out
As it goes in.
Do not blame the penis
For the man.

I'M FOND OF TELLING PEOPLE that the most important sex organ is not located between the waist and knees, but rather between the ears, and I do believe that the brain is our most important sex organ. But without our genitals, well, sex wouldn't be the same, would it?

In society at large, these body parts are, for the most part, hidden. Apart from our sexual partners, it is almost solely through works of art that we get to see what the other half looks like. Of course, some "art" is really for titillation purposes only, though I'll leave the debate in the Supreme Court of whether or not it is art. However, there is one comment that I would like to make about that type of art, because it does do society in general a disservice. Erotica is not just slice-of-life replication. Because the makers of erotica want to sell as much of their product as they can, these artists are careful to choose men and women who most closely resemble the "ideal," so that the women are all thin with large breasts and the men have bulging muscles and large penises. These "works of art" therefore skew our views of what people should look like, especially when it comes to those parts that are usually hidden from view, leaving many people feeling inadequate.

There is no solution, unless everybody is forced to spend at least one day a year at a nudist colony, but it is an issue that requires consideration. The next time you look at someone of the opposite sex and begin to judge them, or worse, rate them from one to ten, make sure you picture what you look like in the nude before you set the level of that imaginary measurement bar. If you knew that you were going to be judged according to the same set of standards, I wouldn't be surprised to see the height of that top bar lowered a notch or two.

Walt Whitman (1819–1892)
THIS IS THE FEMALE FORM
from I Sing the Body Electric

This is the female form,
A divine nimbus exhales from it from head to foot,
It attracts with fierce undeniable attraction,
I am drawn by its breath as if I were no more than a
helpless vapor, all falls aside but
 myself and it,
.

Mad filaments, ungovernable shoots play out of it,
the response likewise ungovernable,
Hair, bosom, hips, bend of legs, negligent falling
hands all diffused, mine too diffused,
Ebb stung by the flow and flow stung by the ebb, love-
flesh swelling and deliciously
 aching,
Limitless limpid jets of love hot and enormous,
quivering jelly of love, white-blow and
 delirious juice,
Bridegroom night of love working surely and softly
into the prostrate dawn,
Undulating into the willing and yielding day,
Lost in the cleave of the clasping and sweet-flesh'd day.

I KNOW OUR BRAINS PULSE with electric currents, and while I don't know whether scientists have ever measured whether there is a jolt in those currents when a man sees an attractive woman, it certainly wouldn't surprise me if that were true. And in France, when two people fall in love instantaneously, they call it *le coup de foudre*, the bolt of lightning, and one of those can certainly give you a jolt.

There are dangers, however, in always seeking only the kind of love that sends a quiver up and down your spine. For example, those flashes can be blinding, and you might not be able to see certain qualities about the other person that, when the light show starts to die out and they become visible, make you wonder why you ever were attracted to them in the first place. Alternatively, some very small embers of feeling, given proper care and enough time, can suddenly burst into flame and soon become a roaring fire. Such a fire, if tended diligently, can last a lifetime. So while at one time or another we all play at the role of hunter, if we are wearing the blinders of preconceived notions, we're likely to miss the obvious, about our target. Remember, love blossomed long before Benjamin Franklin and Thomas Edison made their discoveries, so be a careful seeker and don't be too quick to cast aside those candles.

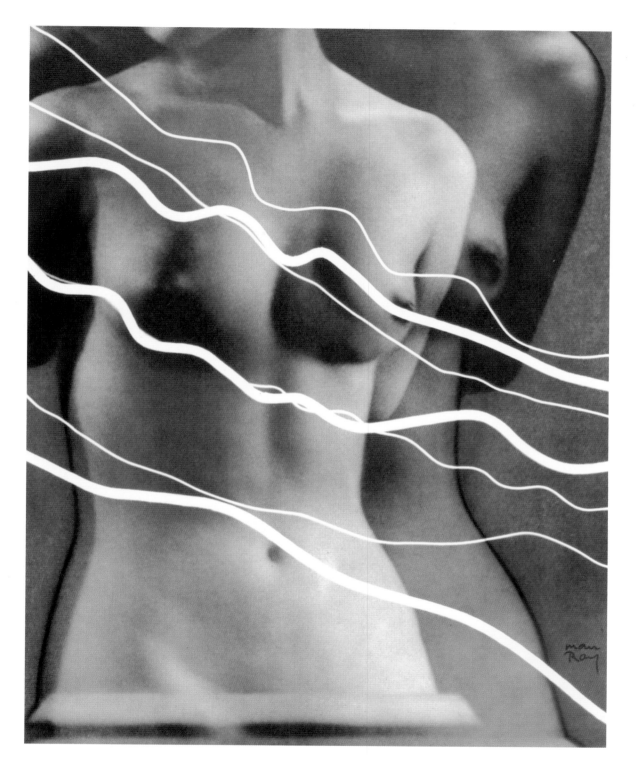

Man Ray (1890–1976). *Électricité*. 1931. Photogravure.

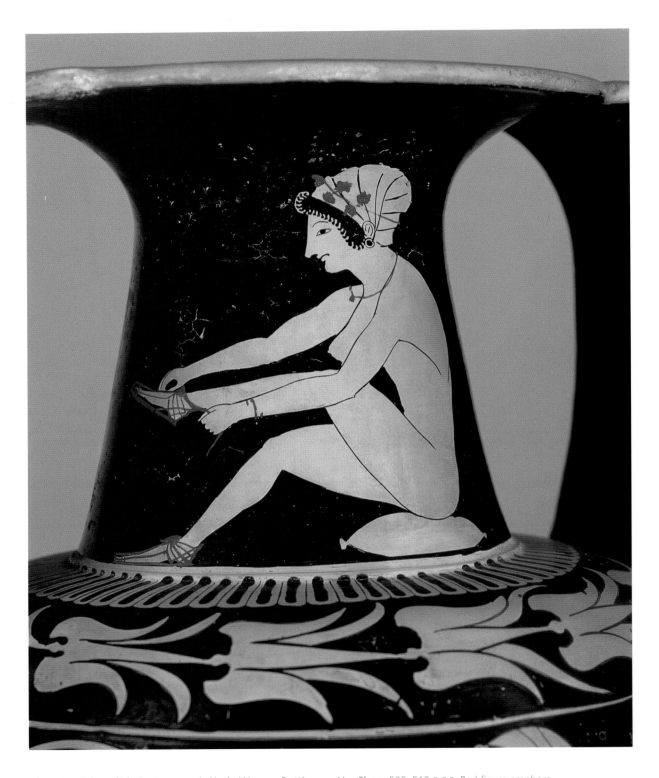

Oltos Vase Painter (6th Century B.C.E.). **Nude Woman Putting on Her Shoe.** 525–510 B.C.E. Red figure amphora.

from *Song of Solomon* (king james version)
HOW BEAUTIFUL ARE THY FEET WITH SHOES

How beautiful are thy feet with shoes, O prince's daughter!
 The joints of thy thighs are like jewels,
 the work of the hands of a cunning workman.
Thy navel is like a round goblet, which wanteth not liquor:
 thy belly is like an heap of wheat set about with lilies.
Thy two breasts are like two young roes that are twins.
. .
How fair and how pleasant art thou, O love, for delights!
This thy stature is like to a palm tree,
 and thy breasts to clusters of grapes.
I said, I will go up to the palm tree,
 I will take hold of the boughs thereof:
 now also thy breasts shall be as clusters of the vine,
 and the smell of thy nose like apples;
and the roof of thy mouth like the best wine for my beloved,
 that goeth down sweetly,
 causing the lips of those that are asleep to speak.
I am my beloved's,
 and his desire is toward me.
Come, my beloved,
 let us go forth into the field;
 let us lodge in the villages.
Let us get up early to the vineyards;
 let us see if the vine flourish,
 whether the tender grape appear,
 and the pomegranates bud forth:
 there will I give thee my loves.
The mandrakes give a smell,
 and at our gates are all manner of pleasant fruits,
new and old,
 which I have laid up for thee, O my beloved.

AS A SEX THERAPIST, I have to picture in my mind's eye what is going on in the bedroom of my clients. I don't always like what I see, but in the case of King Solomon and the Oltos Vase Painter, I derive much pleasure in imagining what they were thinking while creating these two works. In each case, the woman in question is shod, but the artist's eyes are on the rest of her body, which is not. In this section of the Song of Solomon (also known as the Song of Songs), the wise king keeps going back to her breasts, while also mentioning various other bodily parts with such gusto that we can't help but share in his lust for this princess. While the Greek artist covered his model's head and feet, he couldn't stand to hide the rest of her body with any clothing. He, too, is having a fantastic time putting what his eyes are showing him onto that vase.

Neither of these works would be considered very erotic by today's standards, and yet to me, if you allow your mind to follow along with these ancient artists, they are just as suggestive as anything you can find in a XXX-rated video store. Clearly both were enamored with their subject (consider the cushion protecting the Greek model's behind if you don't believe me) and their feelings come through loud and clear. The desire for sex without any personal attachment, as is usually depicted in pornography, is just not as passionate, shall I say not as sexy, as when the two people share a real ardor for each other, as is clearly the case in these two works.

Remy de Gourmont (1858–1915)

HAIR

Translated from the French by Jethro Bithell

There is great mystery, Simone,
In the forest of your hair.

It smells of hay, and of the stone
Cattle have been lying on;
Of timber, and of new-baked bread
Brought to be one's breakfast fare;
And of the flowers that have grown
Along a wall abandoned;
Of leather and of winnowed grain;
Of briers and ivy washed by rain;
You smell of rushes and of ferns
Reaped when day to evening turns;
You smell of withering grasses red
Whose seed is under hedges shed;
You smell of nettles and of broom;
Of milk, and fields in clover-bloom;
You smell of nuts, and fruits that one
Gathers in the ripe season;
And of the willow and the lime
Covered in their flowering time;
You smell of honey, of desire,
You smell of air the noon makes shiver;
You smell of earth and of the river;
You smell of love, you smell of fire.

There is great mystery, Simone,
In the forest of your hair.

I WONDER HOW MUCH TIME we humans spend over a lifetime combing/brushing/cutting/styling/blow drying/curling/straightening/braiding/picking/coloring/shaving/tweezing/primping/shampooing/setting our hair. People are definitely preoccupied with their hair and that of others. Perhaps it's because we humans have lost most of it. I doubt when we were closer in appearance to our cousins the apes and covered with hair, head to foot, that we spent half as much time worrying about the appearance of all those locks. And I'll go one step further and say that the humans who worry the most about their hair are those with the least of it, men who are going bald.

Maybe the reason lies in the fact that hair is the easiest part of our body to manipulate. Losing weight or building muscles is difficult. But changing the appearance of your hair is relatively simple. A woman who goes from being a curly brunette to a straight blonde will have made quite a change in only a few short hours. Yet rarely do such changes really have an effect on our lives. Blondes don't necessarily have more fun unless they're fun-loving to begin with. I'm always waging the battle to get people into the offices of their nearest sex therapist, not because I am trying to increase the income of my colleagues, but because therapy can really make life more fun. Having a better love life can be a significant improvement. So stop spending so much time looking in the mirror and instead spend a little more time looking inside that head of yours, and then make a real effort to make changes that will benefit you.

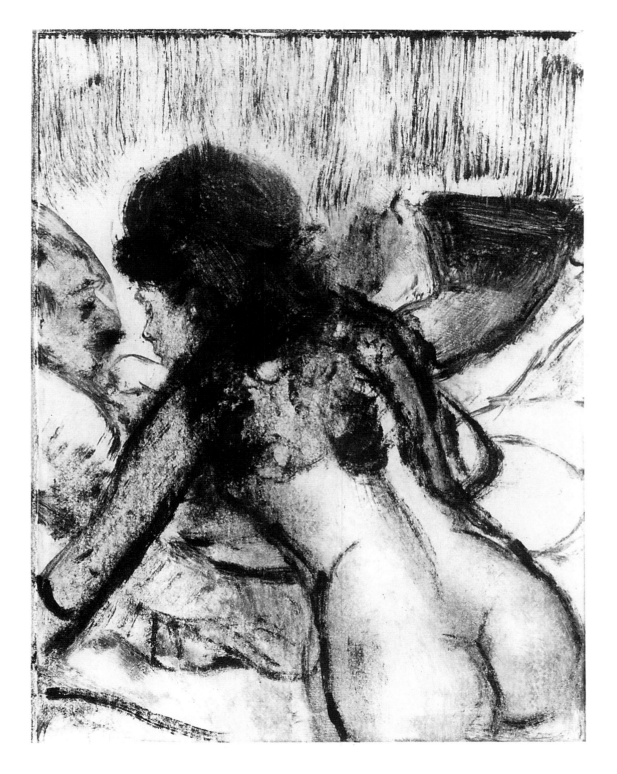

Edgar Degas (1834–1917). **Conversation.** 1876–77. Monotype. 55

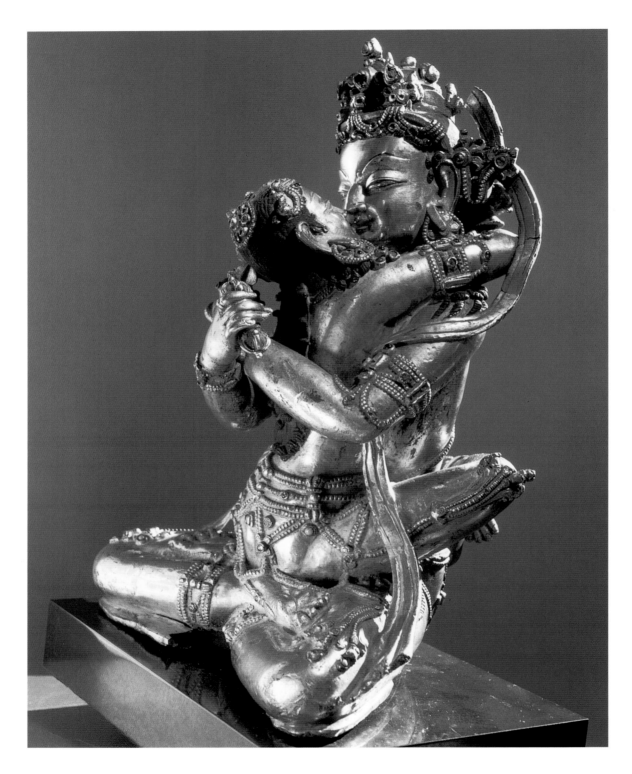

Tibetan (18th Century). **Vajrasattva in Union with the Supreme Wisdom Visvatara.** Bronze with jewels.

Jayadeva (12th century)

SHE PERFORMED AS NEVER BEFORE

From Gita Govinda

Translated from the Sanskrit by George Keyt

She performed as never before throughout the course
 of the conflict of love, to win, lying over his beautiful
 body, to triumph over her lover;
And so through taking the active part her thighs grew
 lifeless, and languid her vine-like arms, and her
 heart beat fast, and her eyes grew heavy and closed;
For how many women prevail in the male performance!

In the morning most wondrous, the heart of her lord
 was smitten with arrows of Love, arrows which went
 through his eyes,
Arrows which were her nail-scratched bosom, her red-
 dened sleep-denied eyes, her crimson lips from a bath
 of kisses, her hair disarranged with the flowers awry,
 and her girdle all loose and slipping.
With hair knot loosened and stray locks waving, her
 cheeks perspiring, her glitter of bimba lips impaired,
And the necklace of pearls not appearing fair because
 of her jar-shaped breasts being denuded,
And her belt, her glittering girdle, dimmed in beauty,
And all of a sudden placing her hands on her naked
 breasts, and over her naked loins, to hide them, and
 looking embarrassed;
Even so, with her tender loveliness ravaged,
 she continued to please!

IN MY OPINION, one of the greatest dangers to a relationship is boredom. Boredom can slowly but surely destroy the passion in a relationship, and once that is gone, it is doomed. But the great thing about this curse is that it is the one most easily cured. There's not much you can do about a houseful of children sapping your energy and stealing your privacy. You can't go to the store to exchange an aging body. And if your job requires you to work twelve hours a day, it's easier said than done to get another that will also pay the bills.

Boredom, on the other hand, can be banished, or at least curtailed. If the two of you have a boring sex life, then force yourselves to make changes. If he always is the initiator, then she must be willing to fire off that starter's pistol once in a while. And if you always use the exact same position, then you have to swear that you won't use it for a month and see what happens.

Of course boredom under the covers is only the tip of the iceberg. But the other types of boredom are also easy to fix. For example, read a book together. Or watch one of those controversial news programs, and then switch it off and continue the discussion. Or on the way to work, write down a list of topics or questions and don't be afraid to pull them out over dinner. As long as you make an effort, you too can smite your partner with arrows of Love.

our bodies

A LOVER MAY BE PLEASED by almost anything that is experienced in lovemaking, but the greatest pleasure seems to be that of two lovers taking mutual delight in each other. Often this pleasure grows as the relationship intensifies and endures, though there are some who would argue in favor of unforgettable ecstasies in brief encounters or "one-night stands."

Roy Fuller (1912–1991)
MYTHOLOGICAL SONNET XVI

How startling to find the portraits of the gods
Resemble men! Even those parts where we
Might have expected to receive the odds
Are very modest, perhaps suspiciously.
For we cannot forget that these aloof and splendid
Figures with negligible yards and curls
Arranged in formal rising suns descended
Often, with raging lust, on our astonished girls—

No doubt because they were intimidated
By their own kind (those perfect forms that man,
Ironically, has always adulated)
And craved the extravagance of nature's plan.
So that humanity's irregular charms
In time fused with divine breasts, buttock, arms.

THAT THOSE WHO LIVED in ancient times should have thought that their gods looked like humans, or that the universe revolved around our little planet, makes sense because they couldn't imagine many other possibilities. But we, who have made so many discoveries, should know better, and yet we insist on making gods of humans, even if it's only for fifteen minutes.

Humans aren't perfect. This is an immutable law of nature. Most of us have so many flaws that we're weighed down by them, but even those individuals who manage to climb a small ways skyward don't have what it takes to get to heaven on their own. But rather than give them a boost, we do our best to pull our heroes and heroines back down into the muck.

Those residents of Mount Olympus who starred in the tragedies and sitcoms of their day, were better suited to the task. For no matter what they did in the minds of men, they never had to face the terrors of living with their audience, or themselves.

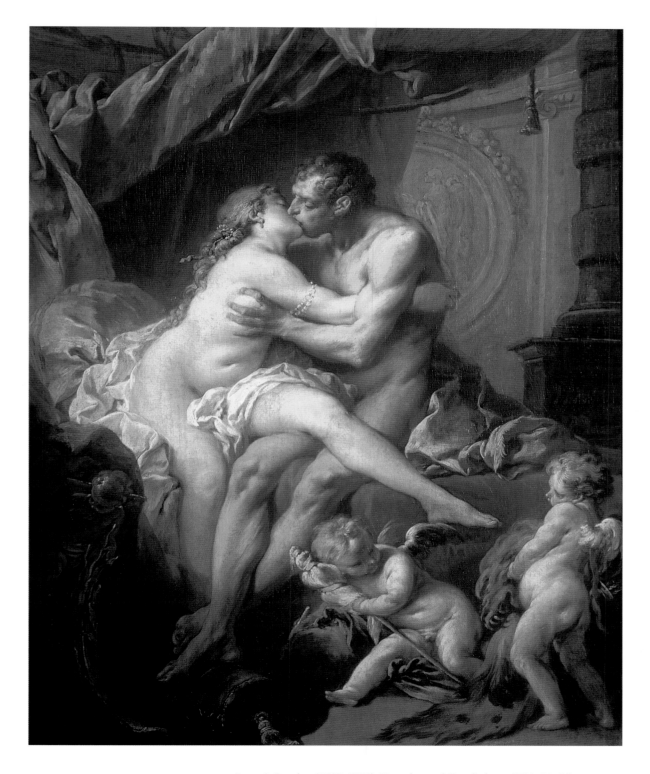

François Boucher (1703–1770). **Hercules and Omphale.** c. 1731–34. Oil on canvas.

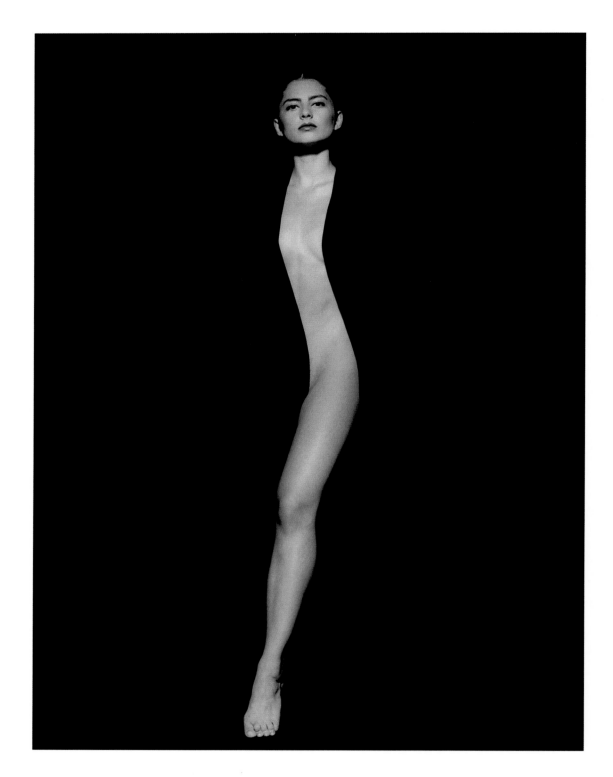

Tono Stano (b. 1960). **Sense.** 1992. Gelatin-silver print.

Denise Levertov (b. 1923)
OUR BODIES

Our bodies, still young under
the engraved anxiety of our
faces, and innocently

more expressive than faces:
nipples, navel, and pubic hair
make anyway a

sort of face: or taking
the rounded shadows at
breast, buttock, balls,

the plump of my belly, the
hollow of your
groin, as a constellation,

how it leans from earth to
dawn in a gesture of
play and

wise compassion—
nothing like this
comes to pass
in eyes or wistful
mouths.
 I have

a line or groove I love
runs down
my body from breastbone
to waist. It speaks of
eagerness, of
distance.

 Your long back,
the sand color and
how the bones show, say

what sky after sunset
almost white
over a deep woods to which

rooks are homing, says.

HOW WELL DO YOU KNOW
your lover's body? Have you
ever really explored it? Have
you touched, poked, prod-
ded, stroked all over his or
her body, not just the obvi-
ous, sensuous spots? Do you
know what areas are tick-
lish? Do you know which
parts are particularly sensi-
tive? Where your partner
likes to be scratched? Or
rubbed? Or licked?

 If you've never gone on
such an exploratory journey,
then I suggest you do. You
can learn things about your
lover that you can use at
other times when you're
more intent on giving them
pleasure than satisfying your
curiosity. And like a true
explorer, leave no stone
unturned. Play at being
Lewis and Clark, and map
every inch of each other's
bodies. Use all your senses.
Look, touch, taste, and sniff
everywhere. It will add a new
degree of intimacy that can
actually improve your relation-
ship. And when you're both
done, it will no longer be your
bodies but our bodies.

Denise Levertov (b. 1923)
THE WIFE

A frog under you,
knees drawn up
ready to leap out of time,

a dog beside you,
snuffing at you, seeking
scent of you, an idea unformulated,

I give up on
trying to answer my question,
Do I love you enough?

It's enough to be so much here. And
certainly when I catch

your mind in the
act of plucking
truth from the dark surroundingnowhere

as a swallow skims a
gnat from the
deep sky,

I don't stop to ask myself
Do I love him? but
laugh for joy.

IN JEFF KOONS'S *Jeff on Top (Dirty),* clearly the two lovers are not in their bedroom, but some place outdoors in nature. In *The Wife,* nature also is everywhere around this couple. Sex is natural and should be surrounded by nature, yet so many couples only do "it" in a darkened bedroom, as hidden from Mother Nature as possible. While I am not suggesting that people risk getting arrested by having sex wherever the mood strikes them, it might be a good idea every once in a while to seek out a secluded area where you can commune with nature while copulating with each other. The feelings that you will derive will not be of the intellectual sort, but may make you laugh from the sheer exhilaration of being au naturel.

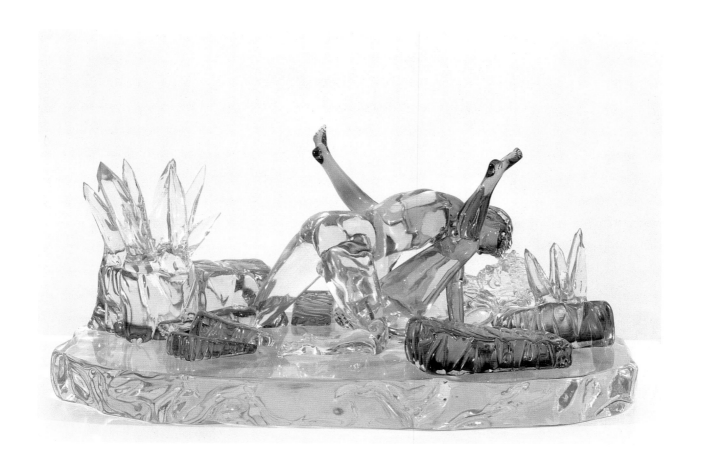

Jeff Koons (b. 1955). **Jeff on Top (Dirty)**. 1991. Glass.　65

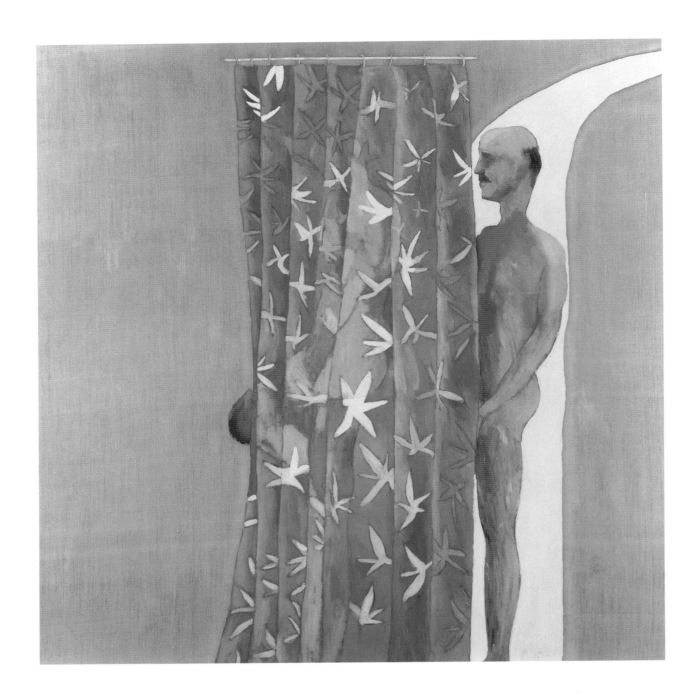

David Hockney (b. 1937). **Two Men in a Shower.** 1963. Oil on canvas.

John Wilmot, Earl of Rochester (1647–1680)
SONG

Love a woman? You're an ass!
 'Tis a most insipid passion
To choose out for your happiness
 The silliest part of God's creation.

Let the porter and the groom,
 Things designed for dirty slaves,
Drudge in fair Aurelia's womb
 To get supplies for age and graves.

Farewell, woman! I intend
 Henceforth every night to sit
With my lewd, well-natured friend,
 Drinking to engender wit.

Then give me health, wealth, mirth, and wine,
 And, if busy love entrenches,
There's a sweet, soft page of mine
 Does the trick worth forty wenches.

TOO OFTEN THE WORD "dirty" is associated with sex when in reality we should look at it as good, clean fun. Obviously sex can be dirty, especially when sexually transmitted diseases are involved, but if two people love each other, and if they are practicing safe sex, then the spirit should be anything but dirty, as the feelings that result from having sex are euphoric and satisfying. And to ensure that sex is as delightful as possible, I always tell couples to add some variety. People shouldn't limit themselves to the bedroom but should use every room in the house, including the bathroom.

To many people, the epitome of "dirty" sex involves two people of the same sex, as in David Hockney's painting and John Wilmot's poem. In this day and age, we are all trying to give the utmost respect to people of any sexual preference, as we should, but the Earl of Rochester is no more open-minded than any bigot you might run into today. His attitude toward women is certainly distasteful, which goes to show you that it is not sexual preference which should be counted as important when judging others, but character.

Pierre de Ronsard (1524–1585)

TO HIS MISTRESS

Translated from the French by Charles Sullivan

Many people freed of their bodies
might find themselves in strange places,
amazingly transformed—one changed
into a snake, another changed into a stone,

one into a flower, another into a bush,
one into a wolf, another into a dove,
one seeing himself become a stream,
another a darting swallow.

But I would rather become a mirror
so that you would always look at me,
or maybe your favorite blouse
so you would wear me often.

I would gladly become water
while I bathed your body,
then I could be made of perfume
to envelop you with scent.

I would be the garment
covering your lovely breasts,
I would be the necklace
adorning your beautiful throat.

Yes, I want to be the coral beads
that you touch to your lips—
all night and all day I'd kiss
your lips, your mouth, like this.

THE IDEA OF WANTING to melt into your lover is beautifully illustrated both in Ronsard's poem and Claudel's sculpture. During intercourse, two lovers do become one, and the resulting orgasmic intensity is something they would like to re-create permanently by becoming one forever.

It's a wonderful sentiment, but it also has an inherent danger. Two people cannot literally become one except in a work of art. We are all individuals, with separate wants and needs, and there is no getting around that. When some couples discover that they cannot become one, that they are not so-called soul mates, whatever that means, then disappointment sets in and they drift apart. They are seeking the impossible, and so it becomes impossible for the relationship to last. For a healthy relationship it is far better to recognize that you are each unique individuals who from time to time, in a kiss or in sexual union, do become one. Enjoy those moments as much as possible, but also learn to appreciate the qualities you each have as individuals and you'll have a much stronger relationship.

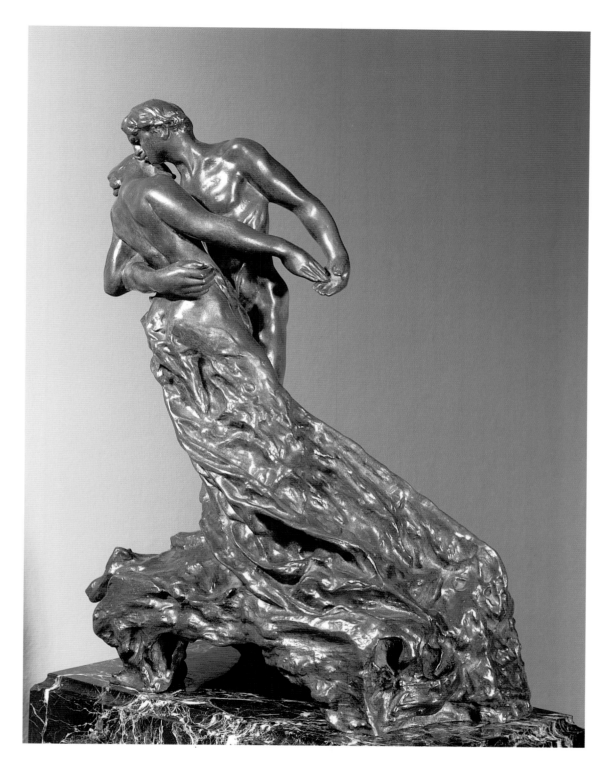

Camille Claudel (1864–1943). **La Valse.** 1905. Bronze.

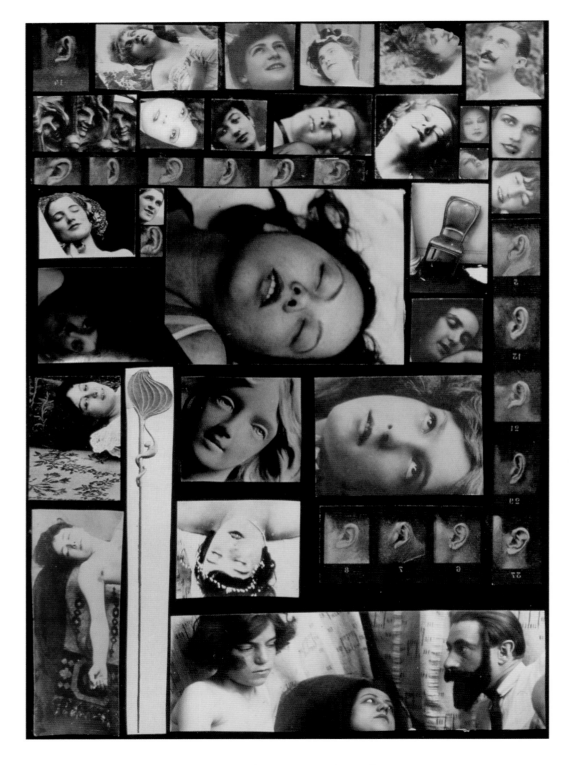

Salvador Dalí (1904–1989). **The Phenomenon of Ecstasy.** 1933. Photo-collage.

William Blake (1757–1827)

THE QUESTION ANSWER'D

What is it men in women do require?
The lineaments of Gratified Desire.
What is it women do in men require?
The lineaments of Gratified Desire.

TO ORGASM, to climax, to come, to bring off, to get one's rocks off, to shoot one's wad, to shake and shiver, to pop one's cork is most definitely something that is sought after by both sexes. Achieving sexual gratification may not be as important as breathing, drinking, eating, and sleeping, but it's next in line and we all wonder at those individuals who take vows of celibacy and sacrifice this supreme pleasure because we know how hard it is to do.

But just as it is awful to have difficulties breathing, drinking, eating, and sleeping, it is also terrible to have trouble obtaining an orgasm. I see such people in my practice all the time and when I am able to help them overcome this difficulty they can't thank me enough. All I can say to anyone who has such problems is that there is help and rather than suffer in silence, I suggest that you toss aside any embarrassment that you might have and make an appointment to see a sex therapist.

Muriel Rukeyser (1913–1980)

LOOKING AT EACH OTHER

Yes, we were looking at each other
Yes, we knew each other very well
Yes, we had made love with each other many times
Yes, we had heard music together
Yes, we had gone to the sea together
Yes, we had cooked and eaten together
Yes, we had laughed often day and night
Yes, we fought violence and knew violence
Yes, we hated the inner and outer oppression
Yes, that day we were looking at each other
Yes, we saw the sunlight pouring down
Yes, the corner of the table was between us
Yes, bread and flowers were on the table
Yes, our eyes saw each other's eyes
Yes, our mouths saw each other's mouth
Yes, our breasts saw each other's breasts
Yes, our bodies entire saw each other
Yes, it was beginning in each
Yes, it threw waves across our lives
Yes, the pulses were becoming very strong
Yes, the beating became very delicate
Yes, the calling the arousal
Yes, the arrival the coming
Yes, there it was for both entire
Yes, we were looking at each other

IN A SENSE YOU COULD SAY that "yes" is the key word in any relationship. Every relationship starts with a question, Will you go out with me? which is answered by a yes. And as the relationship progresses there are more and more of these affirmatives. But if the relationship starts to sour at any point, then the yes often becomes a no. Those first negative responses are like an infection—a few germs which start to multiply so that eventually they overwhelm the positive.

If you sense that you're saying no to your partner as an almost automatic response, or if your partner starts to do that with you, then that ought to tell you that you have a problem brewing. The best way to avoid such problems is to make a point of saying yes as often as you can. Often that will mean some self-sacrifice. It will mean giving up what you want to do to please the other person. Obviously, if one person is always giving in, that also spells trouble. But if both can say yes a majority of the time, almost without thinking about it, then that is the sign of a very healthy relationship.

So be aware of the times you say no. Listen to yourself and don't be afraid to change that no to a yes. And if you're really hesitant about responding favorably, then remember that the frequency of saying no is like an early warning signal. So, think about saying yes to the question of going for some relationship therapy.

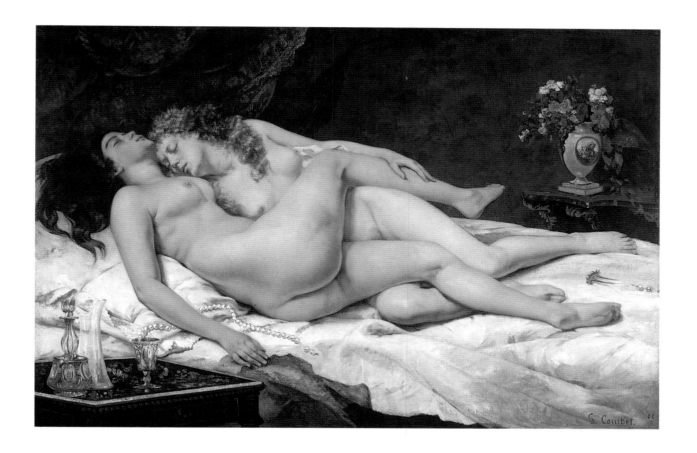

Gustave Courbet (1817–1877). **The Two Friends.** 1867. Oil on canvas.

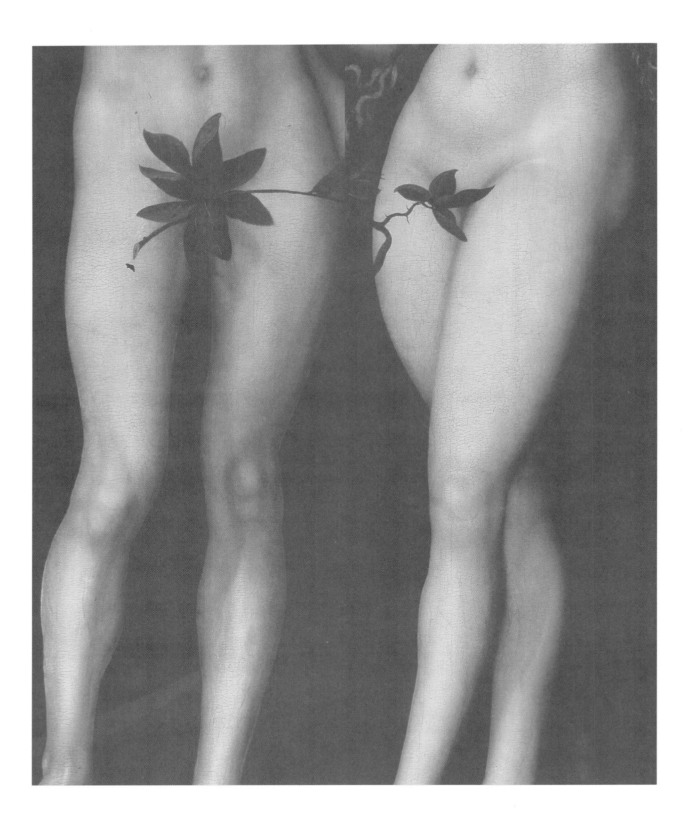

nobody's perfect

EVER SINCE ADAM AND EVE, it seems that to be human is to be imperfect. We have learned to love one another in spite of our imperfections, or in some instances because of them. Even then, however, the beloved may be so special in the lover's eyes that the very lack of perfection takes on a kind of beauty of its own. "It's a very ugly nose, but it's her nose," the lover thinks, or "his nose," as the case may be.

from *Genesis* (king James Version)

ADAM AND EVE

Now the serpent was more subtil than any beast of the field which the LORD God had made. And he said unto the woman, Yea, hath God said, Ye shall not eat of every tree of the garden?

And the woman said unto the serpent, We may eat of the fruit of the trees of the garden:

but of the fruit of the tree which is in the midst of the garden, God hath said, Ye shall not eat of it, neither shall ye touch it, lest ye die.

And the serpent said unto the woman, Ye shall not surely die:

for God doth know that in the day ye eat thereof, then your eyes shall be opened, and ye shall be as gods, knowing good and evil.

And when the woman saw that the tree was good for food, and that it was pleasant to the eyes, and a tree to be desired to make one wise, she took of the fruit thereof, and did eat, and gave also unto her husband with her; and he did eat.

And the eyes of them both were opened, and they knew that they were naked; and they sewed fig leaves together, and made themselves aprons.

I AM NOT AN ULTRA-FEMINIST. I enjoy it when men open doors for me, and I especially enjoy it if they pick up the tab for dinner. But while I may value some old-fashioned concepts, because I have experienced what it is like to be treated unequally, I value more than most the freedoms that women won in the last century. In the orphanage where I spent six years in Switzerland, we girls were not permitted to engage in book learning, but instead were taught to be housemaids. This did not sit well with me, and while I snuck borrowed books into my room late at night, I felt strongly how unfairly I was being treated.

Now, much of the suffering we women have endured comes because of the story of Adam and Eve. This biblical "myth" was used as the basis to consider us women as men's chattel for thousands of years. Of course the fact that men are stronger had a lot to do with why they maintained the upper hand. But deep down they must have known that their attitude toward women was wrong, and so they justified their actions by creating a story that gave them permission to lord it over us all those years.

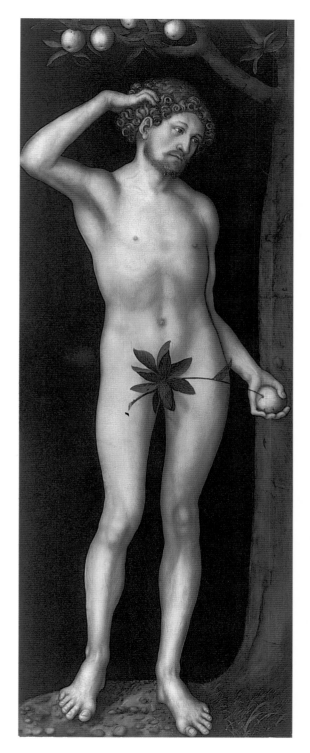
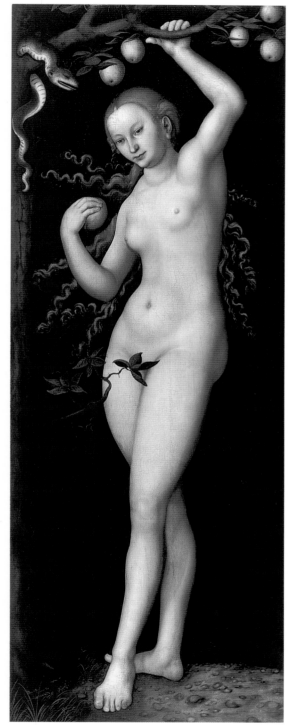

Lucas Cranach the Elder (1472–1553). **Adam and Eve.** c. 1530. Oil on canvas.

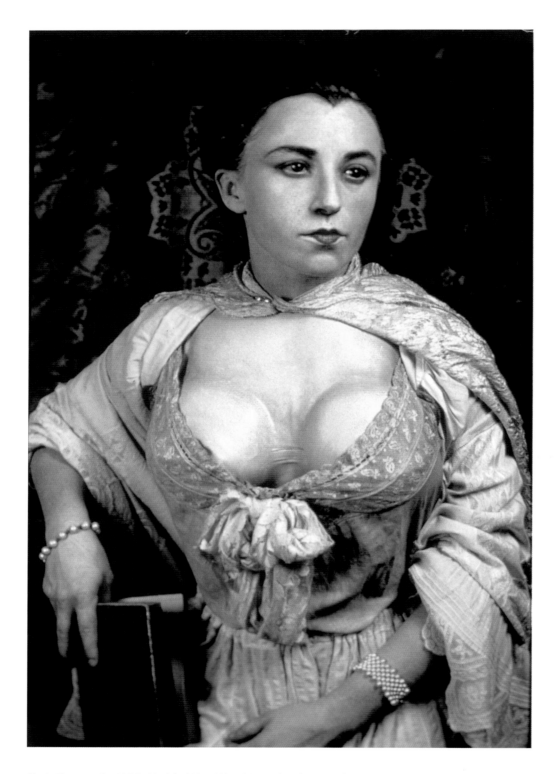

Cindy Sherman (b. 1954). **Untitled No. 183**. 1988. Color photograph.

Robert Herrick (1591–1674)

DELIGHT IN DISORDER

A sweet disorder in the dress
Kindles in clothes a wantonness:
A lawn about the shoulders thrown
Into a fine distraction,
An erring lace, which here and there
Enthralls the crimson stomacher,
A cuff neglectful, and thereby
Ribbands to flow confusedly,
A winning wave (deserving note)
In the tempestuous petticoat,
A careless shoestring, in whose tie
I see a wild civility,
Do more bewitch me, than when art
Is too precise in every part.

ONE OFTEN READS about some beautiful actress or gorgeous model who sits home alone at night because she can't find a man. Why aren't the phones of these women ringing off the hook? Because perfection can scare people off. Since most people know that they're not perfect, they assume that someone who is, or at least approaches perfection, will automatically reject them. Because of their beauty and their fame, these women become like goddesses and so seem unreachable to mortal men.

While we all say that we'd like to have a partner who is a "10," most people wouldn't be quite comfortable with someone like that. Like Robert Herrick, we feel more comfortable when our partners are not "too precise in every part."

In her photograph, Cindy Sherman presents herself in a period costume with an enormous chest. Showing off one's attributes in this way will attract the attention of men, but just being a woman, no matter the size of your breasts or buttocks, is enough to draw men to your side. When I was a teenager, because I was very short, I was certain that I would never find anyone to marry me. But that turned out not to be true. Many teenage girls worry about their looks until they change into women and realize that men are looking quite differently at them. Today, many women decide to augment the size of their breasts. It is sad that these women still have the anxieties that young girls have about their looks and thus undergo plastic surgery in order to feel beautiful.

William Shakespeare (1564-1616)
SONNET CXXX

My mistress' eyes are nothing like the sun;
Coral is far more red than her lips' red;
If snow be white, why then her breasts are dun;
If hairs be wires, black wires grow on her head.
I have seen roses damask'd, red and white,
But no such roses see I in her cheeks;
And in some perfumes is there more delight
Than in the breath that from my mistress reeks.
I love to hear her speak, yet well I know
That music hath a far more pleasing sound;
I grant I never saw a goddess go;
My mistress, when she walks, treads on the ground:
 And yet, by heaven, I think my love as rare
 As any she belied with false compare.

READING THIS POEM, and looking at the Picasso painting, made me think of an oldies song whose chorus went something like: "If you want to be happy for the rest of your life, never make a pretty woman your wife, so from my personal point of view, get an ugly girl to marry you." Certainly seeking out a woman who is "arm candy" can be problematic. Not only must the man compete for her charms initially, but also he must never let his guard down. Even if he is not the jealous type, other males will try to compete despite that ring on her finger.

There's another problem with beauty, which is that it fades with time. If the only reason that a man is attracted to a particular woman is her looks, how long will his attraction last? And if his main criterion for choosing a woman is her appearance, what are the chances that he will sooner or later find himself distracted by the sight of a woman even more beautiful?

Any potential mate will have some assets from the palette that composes the human condition—such as intelligence, wit, a true heart, strength, wealth, a wonderful family, special skills, and beauty. The great sparkle of beauty is the one that first attracts the eye, but in choosing a mate, beauty should not be allowed to shine so brightly that it blinds the eye to all the others. Yes, beauty is an asset, but it is not more important than any of the others, and in the long run, it is perhaps less so. So when seeking a mate, instead of wearing rose-colored glasses that enhance beauty's power, don some sunglasses and spend some time investigating the object of your desire more thoroughly.

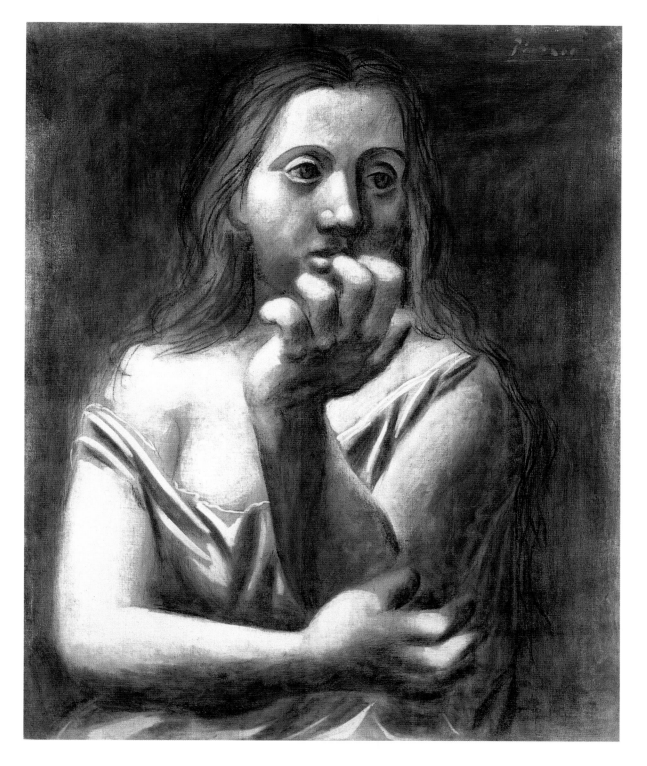

Pablo Picasso (1881–1973). **Bust of a Woman.** 1923. Oil with black chalk on canvas.

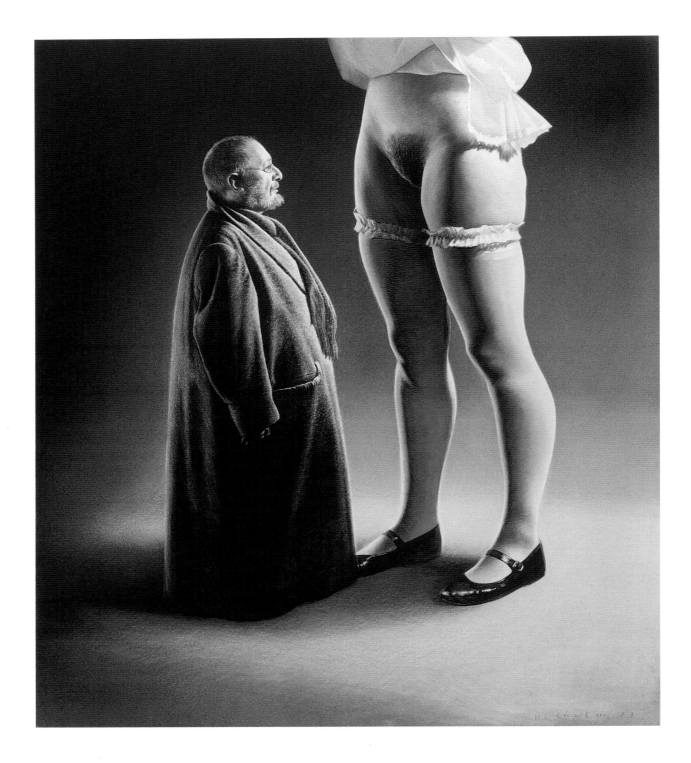

Gottfried Helnwein (b. 1948). **Lulu.** 1988. Watercolor on cardboard.

Charles Baudelaire (1821–1867)

GIANTESS

Translated from the French by Charles Sullivan

Back when Nature in her lustful heat
was conceiving monstrous children day after day,
I would have liked to live close to a gigantic young
 female,
like a sensuous cat at the feet of a queen.

I would have liked to observe her body blooming
 with her soul
and growing ever larger as she played her wild games;
to discover if her heart concealed a burning passion
behind the humid mists which swirled in her eyes;

to explore her gorgeous shape at leisure;
to crawl on the slopes of her enormous knees,
and sometimes in summer, when the relentless sun

exhausted her, when she stretched out across the
 countryside,
to sleep nonchalantly in the shade of her breasts,
like a peaceful village at the foot of a volcano.

IN GENERAL, women are shorter than men, and so in most couples, it is the male who is taller than the female. Of course there are couples in whom the situation is reversed. And there are men who prefer women who are bigger than they are. They may not go to the extreme of sharing Baudelaire's fantasy of being with a giantess, but they prefer women who have more to offer them than less.

People often ask me whether their particular attraction or habit in the sexual realm is "normal." If someone prefers chocolate to vanilla, or the other way around, no one worries what other people think, but in the sexual arena, people feel pressured to conform. As long as a person's predilections aren't dangerous in any way, either to themselves or to anyone else, then they shouldn't be so concerned about what others are doing or not doing. Self-acceptance is as important as societal open-mindedness.

Robert Herrick (1591–1674)

THE VISION

Sitting alone (as one forsook)
Close by a silver-shedding brook;
With hands held up to love, I wept;
And after sorrows spent, I slept.
Then in a vision I did see
A glorious form appear to me:
A virgin's face she had; her dress
Was like a sprightly Spartaness.
A silver bow with green silk strung
Down from her comely shoulders hung;
And as she stood, the wanton air
Dangled the ringlets of her hair.
Her legs were such Diana shows,
When tucked up she a-hunting goes;
With buskins shortened to descry
The happy dawning of her thigh:
Which when I saw, I made access
To kiss that tempting nakedness.
But she forbade me, with a wand
Of myrtle she had in her hand;
And chiding me, said, hence, remove,
Herrick, thou art too coarse for love.

IT IS INTERESTING TO ME that despite all the worries and work and pain women go through trying to look a certain way, there is no one universal vision of what the ideal woman should look like. General tastes change from era to era and continent to continent, and certainly individual men add great swaths of variation even to those localized ideals. Primitive statues showed women with very big hips. The models used by artists in the nineteenth century, particularly Courbet, showed women who were well nourished. These days, thin is in, with large breasts, artificial or natural, being an added plus. In some cultures having huge plates inserted in a woman's ears and lips is a fashion must and for many years in China the feet of women of high social class were bound so that they'd be deformed and useless and others would have to carry them wherever they wanted to go. And look at the abundance of tattoos now seen on women; not so long ago tattoos were to be found only on the biceps and torsos of sailors.

Knowing that the ideal shape can change in the blink of an eye, women must learn to accentuate their own best attributes and then find a man who finds them attractive. You can't please everyone, though sadly there are millions of young women who suffer from eating disorders in their attempt to try to follow the latest trends. No one, man or woman, wants not to fit into the society he or she lives in, but to be a slave to fashion is also a mistake. You end up ceding your free will to someone else's rules and if you're not careful, you'll wind up looking like the emperor in his new clothes.

Yves Klein (1928–1962). **Blue Venus.** 1962. Pigment and synthetic resin on plaster cast. 85

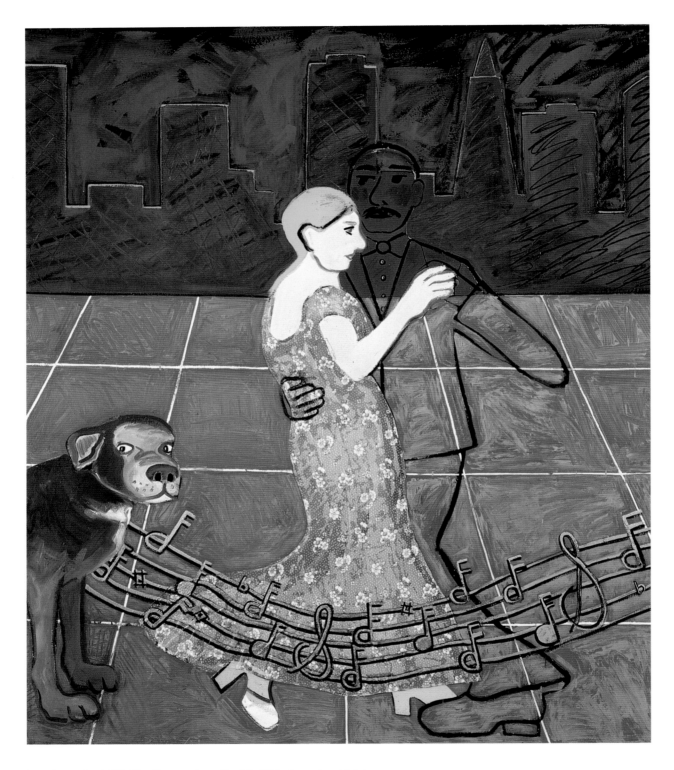

Joan Brown (b. 1938). **The Dancers in a City #2.** 1972. Enamel and fabric on canvas.

Sir Philip Sidney (1554–1587)

DEAR, WHY MAKE YOU MORE

from Astrophel and Stella, Sonnet 59

Dear, why make you more of a dog than me?
If he do love, I burn, I burn in love;
If he wait well, I never thence would move;
If he be fair, yet but a dog can be.

Little he is, so little worth is he;
He barks, my songs in one voice oft doth prove;
Bidden perhaps he fetcheth thee a glove,
But I unbid, fetch even my soul to thee.

Yet while I languish, him that bosom clips,
That lap doth lap, nay lets in spite of spite
This sour-breath'd mate taste of those sugar'd lips.

Alas, if you grant only such delight
To witless things, then Love I hope (since wit
Becomes a clog) will soon ease me of it.

THERE ARE MANY PEOPLE caught in the trap of loving another more than that love is returned, assuming it is returned even fractionally. But as bad as that can feel, it can be even more painful if the person is lavishing love on some pet or an object even further afield, like a favorite sports team. In Sidney's poem, the object of his affection is clearly not someone he can call his own, and he's right to say that eventually her inattention will drive him away. But this situation can also arise within a marriage. One person may end up having an affair, if not with another person, then with his or her job, or get so attached to the children that there's no room left for the spouse, or find that a set of golf clubs is more fun to be with than a spouse.

When someone finds him or herself unloved and there is no marriage license keeping them together, my advice is to make as quick a getaway as possible. We humans have too little time as it is, so there is no point wasting even one additional second being miserable. But when a married couple comes to see me in my office, I can't just tell them to divorce. The situation is easier if there aren't any young children in the picture, but even then, I have to assume that they once loved each other and so I must try to see if I can help them to relight that flame.

But even that process can't go on forever. At some point it becomes clear that both parties would be better off not sharing the same roof. And while that may be sad, staying together is sadder still. If there's one rule about marriage, it's this: never play second fiddle to the dog.

Carol Ann Duffy (b. 1955)
STANDING FEMALE NUDE

Six hours like this for a few francs.
Belly nipple arse in the window light,
he drains the colour from me. Further to the right,
Madame. And do try to be still.
I shall be represented analytically and hung
in great museums. The bourgeoisie will coo
at such an image of a river-whore. They call it Art.

Maybe. He is concerned with volume, space.
I with the next meal. You're getting thin,
Madame, this is not good. My breasts hang
slightly low, the studio is cold. In the tea-leaves
I can see the Queen of England gazing
on my shape. Magnificent, she murmurs,
moving on. It makes me laugh. His name

is Georges. They tell me he's a genius.
There are times he does not concentrate
and stiffens for my warmth.
He possesses me on canvas as he dips the brush
repeatedly into the paint. Little man,
you've not the money for the arts I sell.
Both poor, we make our living how we can.

I ask him Why do you do this? Because
I have to. There's no choice. Don't talk
My smile confuses him. These artists
take themselves too seriously. At night I fill myself
with wine and dance around the bars. When it's finished
he shows me proudly, lights a cigarette. I say
Twelve francs and get my shawl. It does not look like me.

BEING NAKED in front of a lover, who is I hope
also naked, can be exhilarating and intimate
and warm and luxurious. Taking your clothes
off in front of clothed strangers in order to be
able to eat can be degrading and cold and
awful. So it is not the act of removing one's
clothes that counts, but the audience.

But we form an audience wherever we go. If
you're walking down the street you are looking
at dozens of people, and how you react does
count. If you sneer at a fat person, look down
at a short one, stare at a deformed hand or
foot, or even ignore an older person, you are
actively involved in making that person feel
miserable. It may be hard to smile at strangers
at first, but eventually, when you start collect-
ing those returned smiles, you'll find it's not
only easy to smile, but quite rewarding.

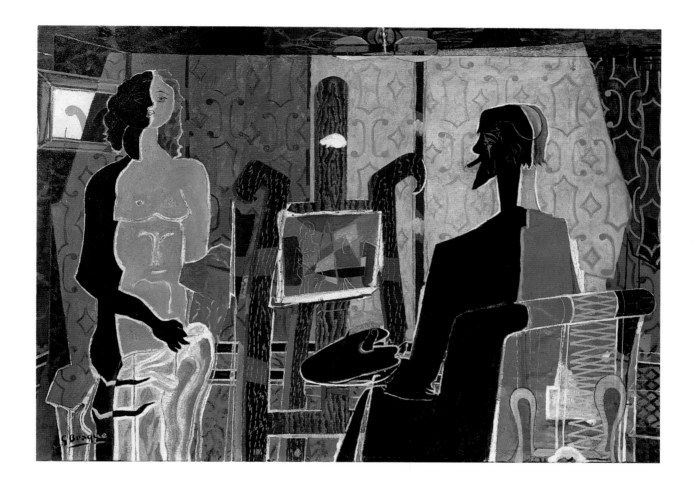

Georges Braque (1882–1963). **Artist and Model**. 1939. Oil and sand on canvas.

why fight it?

SOMETIMES A RELATIONSHIP DOESN'T GO VERY FAR because both potential lovers are hesitant to cross a line between what seems right to them and what seems wrong. More often, however, one is the pursuer, the persuader, while the other at least for a while eludes pursuit, resists persuasion. The resulting frustrations can be the stuff of comedy or tragedy, depending on the outcome.

Christopher Marlowe (1564–1593)
THE PASSIONATE SHEPHERD TO HIS LOVE

Come live with me and be my Love,
And we will all the pleasures prove
That hills and valleys, dales and fields,
Or woods or steepy mountain yields.

And we will sit upon the rocks,
And see the shepherds feed their flocks
By shallow rivers, to whose falls
Melodious birds sing madrigals.

And I will make thee beds of roses
And a thousand fragrant posies;
A cap of flowers, and a kirtle
Embroidered all with leaves of myrtle.

A gown made of the finest wool
Which from our pretty lambs we pull;
Fair-lined slippers for the cold,
With buckles of the purest gold.

A belt of straw and ivy-buds
With coral clasps and amber studs;
And if these pleasures may thee move,
Come live with me and be my Love.

I LOVE ROMANCE, and Christopher
Marlowe is describing a very romantic
scene here, but to me romance is a deli-
cious appetizer, not the main course.
A relationship has to be grounded in
reality. Yes, there are exceptional cases
where two people from opposite ends of
the world meet and live happily ever
after, but if it were my son or daughter
(both thank goodness married to wonder-
ful people) who was being so wooed,
I wouldn't be happy, because I would
feel that such a union just would not
be likely to last.

American (19th Century). **The Proposal.** Scrimshaw.

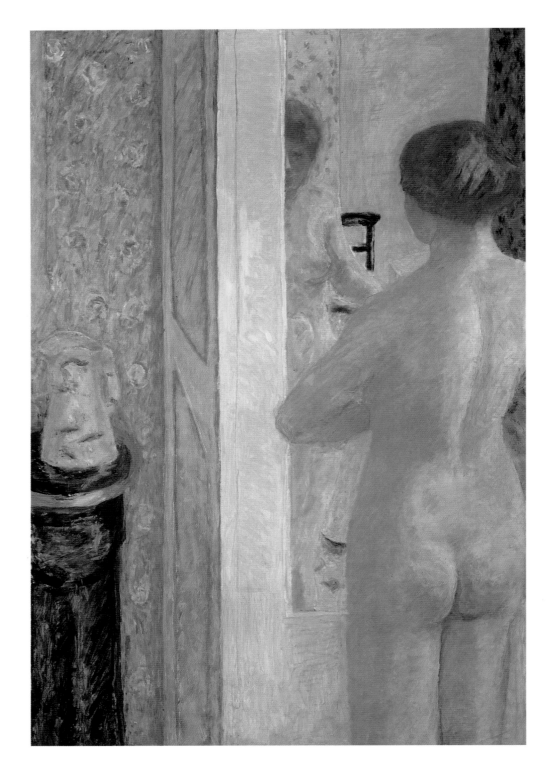

Pierre Bonnard (1867–1947). **The Toilette.** c. 1908. Oil on canvas.

Alan Dienstag (b. 1929)

SYLVIA

Sylvia liked to pretend
That an end in itself
Was not the object of desire,
But that these things
Were on a higher plane,
And lying back with half-closed eyes
Explain the Fourth Dimension, God,
Or any possible extension
Of present fact or future fancy
From Jean-Paul Sartre to necromancy
And all with such cunning misdirection
The Spasm passed without detection.

SOME PEOPLE ARE AFRAID of letting themselves go and having an orgasm. While this may be more common among women, it happens to men too. This condition even has a name—retarded ejaculation. The man can have an orgasm while he is masturbating, but not during intercourse.

Turning one's back on the satisfaction that is derived from sex may be presented as an intellectual stance, as it is with this Sylvia, but one can certainly enjoy the throes of passion without harming one's intellect. The real reason people avoid orgasms is a fear of letting go. Yes, it is the brain that is putting on the brakes, not because sex is something seen as beneath them, but simply because their brains are afraid of deep feelings of any sort. The source of the problem could be something that happened in their childhood or just a mistaken notion that is allowed to settle in and take over. But if you really want to reward your brain, the smart thing to do is not to turn and face the wall and keep your legs together, but instead to roll over and open them wide and allow all of your senses to contribute to your true self, not just those that are under your control.

John Keats (1795–1821)
SHARING EVE'S APPLE

O blush not so! O blush not so!
 Or I shall think you knowing;
And if you smile the blushing while,
 Then maidenheads are going.

There's a blush for won't, and a blush for shan't,
 And a blush for having done it:
There's a blush for thought and a blush for naught,
 And a blush for just begun it.

O sigh not so! O sigh not so!
 For it sounds of Eve's sweet pippin;
By these loosen'd lips you have tasted the pips
 And fought in an amorous nipping.

Will you play once more at nice-cut-core,
 For it only will last our youth out,
And we have the prime of the kissing time,
 We have not one sweet tooth out.

There's a sigh for yes, and a sign for no,
 And a sigh for "I can't bear it!"–
O what can be done, shall we stay or run?
 O cut the sweet apple and share it.

SOMETIMES YOUNG WOMEN will ask me how to get the attention of a young man they are interested in and I often recommend the tried and true formulas. When women carried hankies, they'd drop one in front of the gentleman in question as a way of letting him know of their interest and to give him an opening for conversation when he returned it. Hankies may be passé (though not necessarily) but any item will do, even a cell phone if it's in a protective case.

While blushing might serve the same purpose, not everyone can blush on command. But there are also smiles and winks and licked lips. Running your fingers through your hair can certainly send a message as can adjusting a skirt or undoing a top button of a blouse. And then there's simply looking into the other person's eyes. That can be almost as personal as you can get, and if you can't get your message across that way, then the other person's receiver is definitely either on the fritz or tuned to some other frequency.

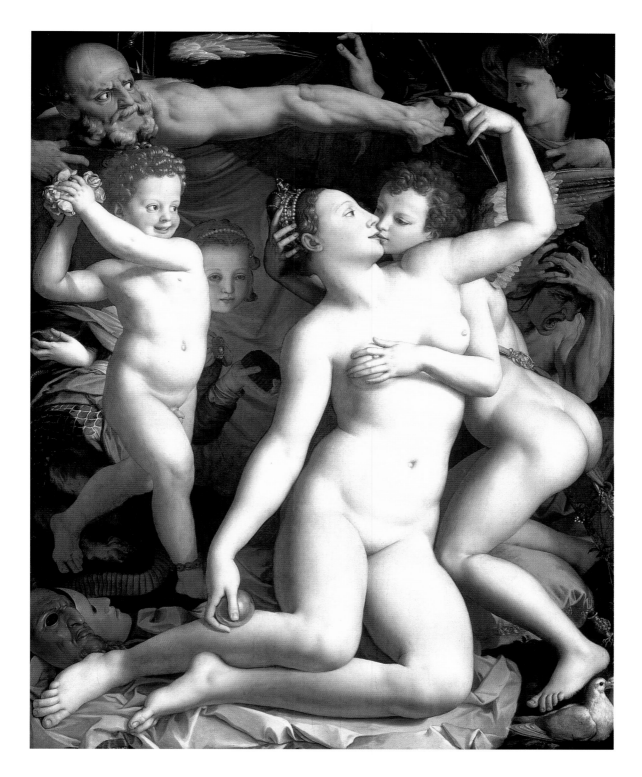

Agnolo Bronzino (1503–72). **Allegory of Venus and Cupid.** 1540–45. Oil on wood.

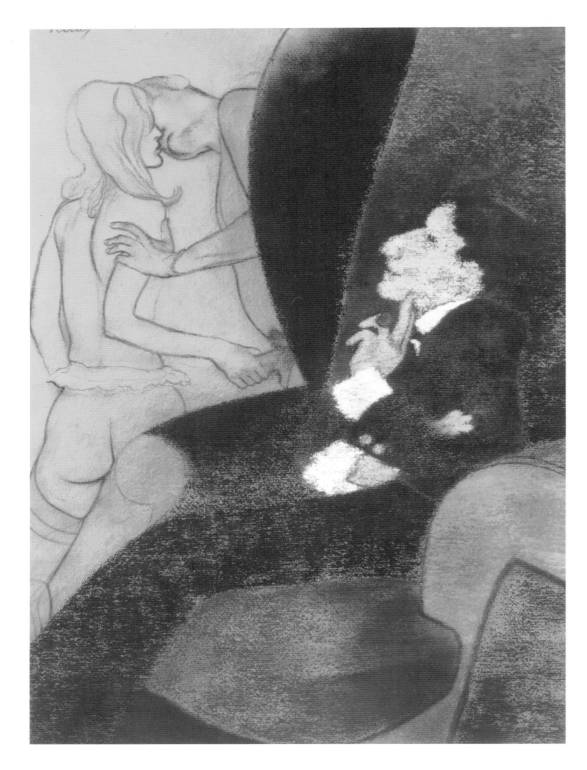

R. B. Kitaj (b. 1932). **His Hour.** 1975. Pastel and charcoal on paper.

Richard Weber (b. 1932)
ELIZABETH IN ITALY

Suddenly she slapped me, hard across the face.
I implored, but she declined to have any further
Social or sexual (so she put it) intercourse with me.
Neither would she give me either a personal picture
Or a lock of her most beautiful hair.
Indeed, she demanded, her exquisite voice
Quite hard, the return of her handkerchief
And any other things (I muttered, "mementoes,"
But she repeated "things") I might have stolen
From her in my privileged position as her servant.
God only knew what had made her ask me
Fetch her the bathrobe that terrible night.
("That beautiful night," I recollected aloud.)
Did I believe our positions were reversed?
(I whitened at the accusation.) Well, then,
She wished to make clear now and for so long
As the relationship ("Madam!" cried I) lasted,
That it could only do so if I went to bed first,
Where she would come at her pleasure.
I could make no clearer sign of my heartfelt
Gratitude and infinite relief at these words
Than by the impassioned and repeated kissing,
There and then, of her magnificent left breast
Which had come out of hiding towards the end
Of her peroration. Whereupon she slapped me again.

THE INTERESTING QUESTION to me in Richard Weber's poem concerned their first night together. Had it been a spur-of-the-moment decision or had she been planning to have sex with her servant for some time? I think it's the latter, for a woman who would slap her servant without hesitation would not have allowed herself to be seduced by someone of a lower station. She knew what she was doing and the servant is not about to be left alone in his bed very often.

What is terrible about such situations, however, is that when she's had enough of him, not only will she stop all contact, but also he'll be out of a job. And if he thinks he's going to get a good letter of recommendation, he'd better think twice. For while she's enjoying the sex, she's not happy to have had to lower her standards this way. Each of those slaps may be hitting his cheek, but they're meant for her own. And so when the pot boils over, which it inevitably will, instead of blaming herself, she'll blame him.

Whether it's with the butler, or the French maid in her little skirt, or the slave brought in from the fields, masters and mistresses have long sought sexual gratification from the help. One reason for this was that splitting up was not "permitted" among the upper classes, and so they exercised their power to obtain what they needed—thus giving new meaning to the phrase, "The butler did it."

Anonymous
O DEAR O
English Folk Song

As I was walking one midsummer morning
To view the fields and the leaves a springing
There was two birds upon the tree
Sounding their notes and sweetly singing
 O dear O what shall I do?
My husband got no courage in him
 O dear O!

All sorts of meat I did provide
All sorts of drink that are fitting for him
But oyster pie and rhubarb too
But nothing would put courage in him
 O dear O what shall I do
My husband got no courage in him
 O dear O!

My husband's admired wherever he go
And every one looked well upon him
By his hands and feet and well shaped eye
But still he got no courage in him
 O dear O what shall I do
My husband got no courage in him
 O dear O!

Seven long years I made his bed
Six of them I lay beside him
And this morning I rose with my maidenhead
For still he had no courage in him
 O dear O what shall I do
My husband got no courage in him
 O dear O!

Come all pretty maidens wherever you be
Don't love a man before you try him
Lest you should sing a song with me
My husband's got no courage in him
 O dear O what shall I do
My husband's got no courage in him
 O dear O!

ALTHOUGH THE LIBIDO is strong, some people's fears are stronger. The woman in the English folk song complains that her husband does not have the courage to make love to her. But the woman in Rudolf Schlichter's drawing isn't waiting for the man to take charge—she is in control.

Rudolf Schlichter (1890–1955). **Dominea mea.** 1927. Watercolor.

102 Henri Matisse (1869–1954). **The Necklace.** 1950. Brush and ink on paper.

Carol Ann Duffy (b. 1955)
WARMING HER PEARLS

Next to my own skin, her pearls. My mistress
bids me wear them, warm them, until evening
when I'll brush her hair. At six, I place them
round her cool, white throat. All day I think of her,

resting in the Yellow room, contemplating silk
or taffeta, which gown tonight? She fans herself
whilst I work willingly, my slow heat entering
each pearl. Slack on my neck, her rope.

She's beautiful. I dream about her
in my attic bed; picture her dancing
with tall men, puzzled by my faint, persistent scent
beneath her French perfume, her milky stones.

I dust her shoulders with a rabbit's foot,
watch the soft blush seep through her skin
like an indolent sigh. In her looking-glass
my red lips part as though I want to speak.

Full moon. Her carriage brings her home. I see
her every movement in my head. . . Undressing,
taking off her jewels, her slim hand reaching
for the case, slipping naked into bed, the way

she always does. . . And I lie here awake,
knowing the pearls are cooling even now
in the room where my mistress sleeps. All night
I feel their absence and I burn.

CAROL ANN DUFFY HAS WOVEN an intriguing story in her poem; one that cannot leave the reader untouched. There is certainly a sexual innuendo between the mistress and her maid, and yet at the same time one can't help but feel a certain revulsion at the attachment the maid has for her mistress's pearls. She lives vicariously through them, in much the way many people choose to fantasize about a famous celebrity rather than settle for a real lover who might not be a "pearl."

There was a time when it was literally impossible to improve one's station in life. A servant had no choice but to look for pleasure wherever it could be found because her lot in life was set, probably at birth. Today, almost anything is possible if one puts one's mind and effort into it. In my opinion, no one should ever settle for someone else's string of pearls. Be it a job or a relationship, if improvements are needed, don't push them off while you live in a fantasy world. Take charge of your life and do whatever has to be done so that you can wear your own set of pearls.

Emily Dickinson (1830–1886)

IN WINTER, IN MY ROOM

In winter, in my room,
I came upon a worm,
Pink, lank, and warm.
But as he was a worm
And worms presume,
Not quite with him at home—
Secured him by a strong
To something neighboring,
And went along.

A trifle afterward
A thing occurred,
I'd not believe it if I heard—
But state with creeping blood;
A snake, with mottles rare,
Surveyed my chamber floor,
In features as the worm before,
But ringed with power.
The very string
With which I tied him, too,
When he was mean and new,
That string was there.

I shrank—"how fair you are!"
propitiation's claw—
"Afraid," he hissed,
"Of me?"
"No cordiality?"
He fathomed me.
Then, to a rhythm slim
Secreted in his form,
As patterns swim,
Projected him.

That time I flew,
both eyes his way,
Lest he pursue—
Nor ever ceased to run,
Till, in a distant town,
Towns on from mine—
I sat me down;
This was a dream.

IN THE WORLD OF FREUD and psychoanalysis, a snake that appears in someone's dream is a phallic symbol, and one could certainly then presume that a dream worm that turned into a snake could be compared to a penis becoming erect, and that the poet fleeing from this snake in her dream had some deep meanings as well.

Of course I am not a psychoanalyst but a therapist, and while I admire psychoanalysts, I take a much more practical approach to life. If a client comes to me saying that she is attracted to some man but also is afraid of him, I don't ask her about her dreams. My job isn't to go backward, but to show her how to make progress toward overcoming her fear of this particular man. I will give her very practical advice that will, I hope, help her to forge this relationship that she desires.

Of course, sometimes there is something in a client's past that needs to be resolved before she can make progress. If the problem is too deep-seated, I will refer this person to someone with a different expertise than I have . . . maybe even someone who will analyze her dreams.

Keith Haring (1958–1990). **Untitled.** 1985. Acrylic on canvas.

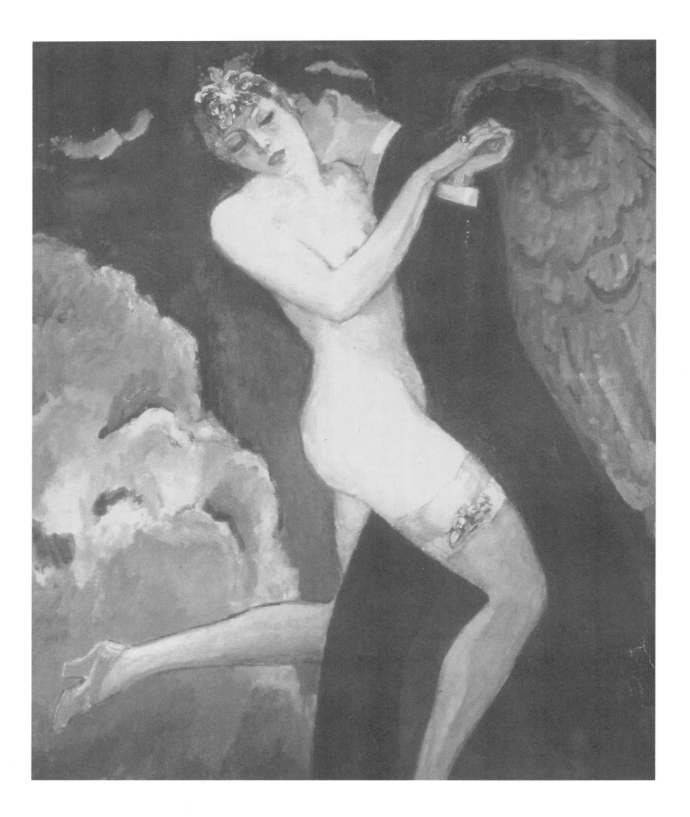

one-night stands

A BRIEF ENCOUNTER may be the only possibility for some lovers, the experience of choice for others. Traditionally women have been less willing than men to engage in so-called "one-night stands," which offer little in the way of love or commitment. Times change, however, and traditions, too. Today more women may be willing to settle for a little loving at a time, while more men are seeking the security of a long-term relationship.

Elinor Wylie (1887–1928)

A LODGING FOR THE NIGHT

If I had lightly given at the first
The lightest favors that you first demanded;
Had I been prodigal and open-handed
Of this dead body in its dream immersed;
My flesh and not my spirit had been pierced:
Your appetite was casual and candid;
Thus, for an hour, had endured and ended
My love, in violation and reversed.

Alas, because I would not draw the bolt
And take you to my bed, you now assume
The likeness of an angel in revolt
Turned from a low inhospitable room,
Until your fiery image has enchanted
And ravished the poor soul you never wanted.

MOST PEOPLE KNOW that we only dream at certain times during the night. Less well known is the fact that men also get erections regularly throughout the night, and both men and women can have orgasms in their sleep, which for men is called a wet dream since it leads to a rather sticky situation.

It should not come as a surprise that our brains are not celibate while we sleep, given how much time we devote to the subject of sex while we are awake. Most of the time we forget our dreams, but once in a while one is so vivid that it sticks. But while dreams may be interpreted, there are no hard and fast answers to be found there. Just because you dream about some past lover doesn't mean that you should drop your current partner and go seeking out this long lost love.

Imogen Cunningham (1883–1976). **The Unmade Bed.** 1957. Photograph. 109

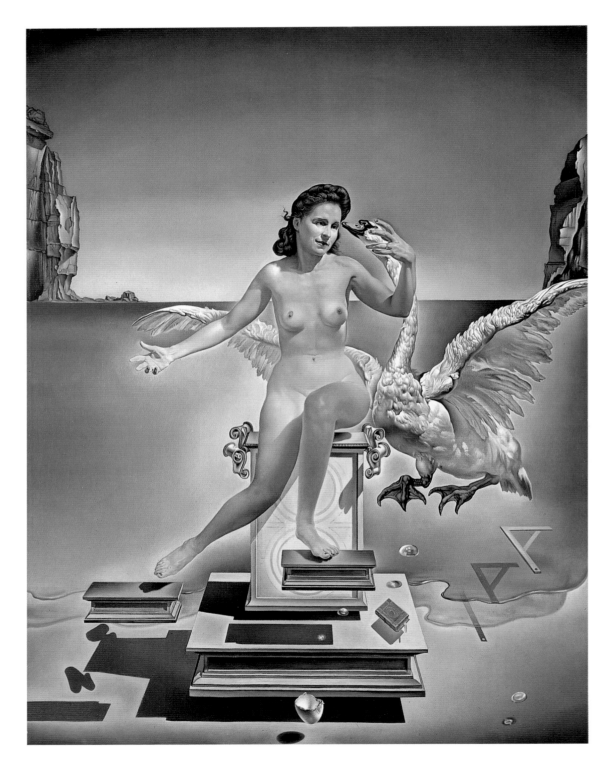

110 Salvador Dalí (1904–1988). **Leda Atómica**. 1949. Oil on canvas.

W. B. Yeats (1865–1939)

LEDA AND THE SWAN

A sudden blow: the great wings beating still
Above the staggering girl, her thighs caressed
By the dark webs, her nape caught in his bill,
He holds her helpless breast upon his breast.

How can those terrified vague fingers push
The feathered glory from her loosening thighs?
And how can body, laid in that white rush,
But feel the strange heart beating where it lies?

A shudder in the loins engenders there
The broken wall, the burning roof and tower
And Agamemnon dead.
 Being so caught up,
So mastered by the brute blood of the air,
Did she put on his knowledge with his power
Before the indifferent beak could let her drop?

I SUPPOSE EVERY GENERATION believes that they are the ones who created sex. They can't believe their parents ever did "it" and as they discover the pleasures sex can bring, they think of these bodily functions as theirs alone. But, of course, this is nonsense, and while our society has made unbelievable advancements in many areas, when it comes to sex, things haven't changed all that much. In fact, despite our so-called sophistication, I wonder if people would be so accepting these days of the thought of a woman making love to a swan, even if it is supposed to be a god in disguise.

This myth has captivated artists, both those who write and those who paint, for as long as this story has been circulated. I am certainly opposed to bestiality, but I am freer in my thinking when it comes to fantasy. If there are women out there who would like to fantasize about what it would be like to live out this myth, my advice would be to go right ahead. Remember, this is not making love to an animal, but to a god in the form of an animal. In fact, you could go one step further and imagine what it would be like to make love to your own partner in the form of some other animal. Maybe you'll find it arousing and maybe not, but it should be a fun experiment. And as with all fantasies, you don't have to reveal to anyone that you've indulged in this particular one. By keeping it private, you won't arouse any negative attitudes, though you may end up arousing yourself quite a bit.

Ernest Walsh (1895-1926)

A SERIOUS POEM

How to win her
To put from my head
 That she is morning
 and evening
 to me
That the wind has carried her fragrance
To wild flowers
 high and hidden
That she is the cool dark doorway
 of my temple
Yet I cannot go there until
 I am dead
That she is nude
 as a glass of water
 and dances before me
Like a white feather blown
 by the wind
That she lies before me
 A long slender stretch of firm white sand
 To put this from my head
To see her as a woman only
To win one night in her bed

SOME LUCKY COUPLES fall in love with each other instantly and simultaneously. In most cases, however, wooing or flirting takes place first, and if the object of desire senses any hint that the pursuer is desperate, then rejection becomes the more likely outcome. It's ironic that some of those people who reject the ardent pleas of a desperate suitor later complain that those they are interested in are afraid of commitment.

And it's not only the desperate suitors who bring about this reaction. How many women will take the first dress they see on the rack? It may have all the attributes they were looking for but instead of rushing off with it to the cashier, they force themselves to look for something even better. We all do this to some extent, but sometimes it's a mistake. Maybe that desperate suitor isn't perfect, but perhaps his or her ardor will more than make up for any imperfections. Playing hard-to-get just because the person who is pursuing you has shown his or her cards may have some hidden costs that ultimately may make you the loser.

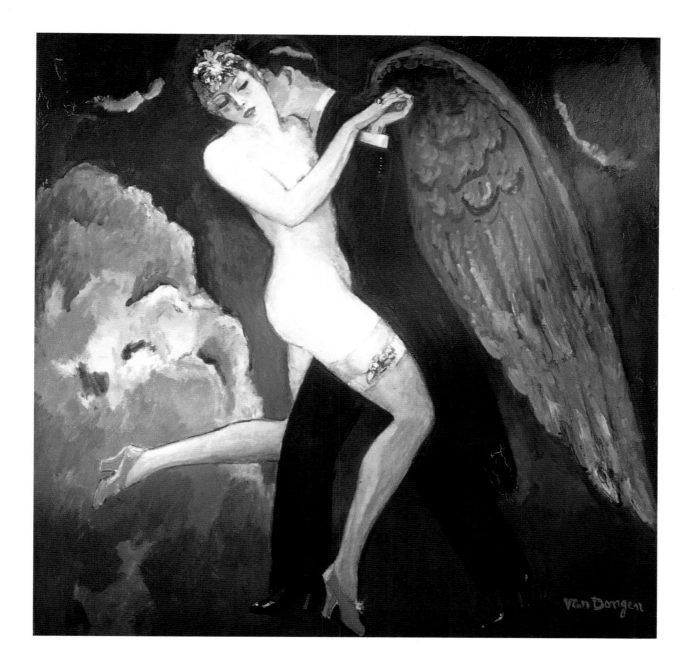

Kees van Dongen (1877–1968). **Tango.** 1923–35. Oil on canvas.　113

Camille Claudel (1864–1943). **Profond pensée**. 1905. Marble.

D. H. Lawrence (1885-1930)

NEW YEAR'S EVE

There are only two things now,
The great black night scooped out
And this fireglow.

This fireglow, the core,
And we the two ripe pips
That are held in store.

Listen, the darkness rings
As it circulates round our fire.
Take off your things.

Your shoulders, your bruised throat!
Your breasts, your nakedness!
This fiery coat!

As the darkness flickers and dips,
As the firelight falls and leaps
From your feet to your lips!

PERHAPS WE HAVE TOO MANY creature comforts nowadays for really great sex. We can control the exact temperature of the room. We can turn night into day with all our lights. We can distract ourselves endlessly with TV and stereos and computers. It's not that I don't like all these devices myself, at least the ones that I can work, but when we totally remove the forces of nature from our lovemaking, perhaps we are losing something vital to our complete enjoyment of it.

What is more romantic than two people naked on a bearskin rug, lying in front of a fire? Yes, there's a rough edge to having sex this way, but it's the type of setting that adds fuel to the passion of the moment. The darkness of the room hides the distractions. The heat from the fire draws out their feelings while the chill of the air makes the two lovers cling closer together.

If there are still many women who have difficulties reaching orgasm, it's in part because they are afraid of letting themselves go. Maintaining control over the very air that surrounds them makes it easier for them to stifle their own feelings. By covering themselves with sheets and blankets they don't allow themselves to feel really naked in front of their lover. By closing the door to the bedroom, they end up worrying more about their sense of privacy than their sense of lust. Maybe those women, and all couples, need to free themselves from the twenty-first century now and then and get in touch with their more primal selves. Not necessarily every time, but once in a while, so that they can enjoy sex the way humans used to, connected with nature instead of alienated from it.

Edna St. Vincent Millay (1892–1950)
I, BEING BORN A WOMAN (SONNET XLI)

I, being born a woman and distressed
By all the needs and notions of my kind,
Am urged by your propinquity to find
Your person fair, and feel a certain zest
To bear your body's weight upon my breast:
So subtly is the fume of life designed,
To clarify the pulse and cloud the mind,
And leave me once again undone, possessed.
Think not for this, however, the poor treason
Of my stout blood against my staggering brain,
I shall remember you with love, or season
My scorn with pity,—let me make it plain:
I find this frenzy insufficient reason
For conversation when we meet again.

A MODERN WOMAN, that Edna St. Vincent Millay. Her words are more similar to the views men have traditionally held; let's have sex but then I don't want to have to speak to you again. Because women always ran the risk of pregnancy, they used to put that concern ahead of their own pleasure. But these days, when the risk of pregnancy can be minimized, I get letters from both sexes complaining that their partner does not want as much sex as they require. Since lovers are dissimilar in so many ways, it's not surprising that they would not share the same sexual appetite. Finding out how to reach a compromise on this issue is an important ingredient to having a successful relationship. The first step is to realize that such differences do exist, and not to assume that it's always the male whose need for sex is stronger.

Gerhard Richter (b. 1932). **Ema—Akt auf der Treppe.** 1966. Oil on canvas.

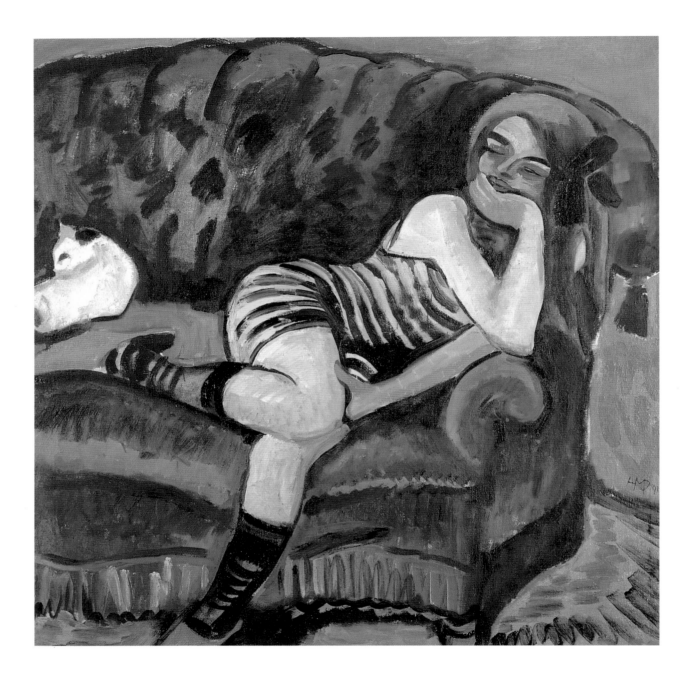

Max Pechstein (1881–1955). **The Green Sofa.** 1910. Oil on canvas.

Simon Armitage (b. 1963)
THE VISITOR

This is
a hard one to explain away: your tall
long-standing Fräulein arriving
unannounced on my doorstep with a toothbrush
and the clothes she stands in. I bundle her inside;

so much laundry before the cloudburst
and for an hour at least she sits and teases
particular fibres from her coat lining, declines
all manner of refreshment.
But we have all night.

Two in the morning. Everywhere we telephone
you are elsewhere; out apparently
in thick rain walking the parish boundary,
circling the house
where your mother holds fort, or any house

where my guest's impeccable English might ring out
and deceive you. We imagine you emerge
like a man dipped in silver, one quarter of the moon
enough to colour and usher you out of the bottom field,
see you clear

of the nettles. Four or five more strides
will bring about the view
you have outlined so graphically: two roads parting,
their streetlights marking a flawless
almost unbelievable Y.

Tomorrow you fish
for the full story. You know my house,
enough blankets
to sleep the whole Rhine Army
but one bed only.

And we will not speak of taking sides.
Only that she left as arranged, likening

your mother's hatchback to a Black Maria.
Then our exchange; my 'Isn't that what friends are
for?'
And your 'Some day

I'll do the same for you Buddy. Don't worry.'

ONE OF THE REASONS so many people share
the fantasy of being on a desert island with
their lover is that being so cut off denies the
opportunity for all of the entanglements
that seem to develop around a relationship,
like a spider's web. If your significant other
is in the corner of the room laughing hyster-
ically with your best friend, you're going to
wander on over to see what's happening.
No matter how close you are, there's this
sudden fear that you might lose your part-
ner to someone else, or even a small part of
him or her.

We all treasure our freedom, yet we
would also like to be able to keep our sights
on our partner 24/7. Even more, we'd like to
pry inside that person's mind to make sure
no mischievous thoughts about anyone else
have snuck inside. Is there anybody who is
part of a couple who doesn't have at least a
fleeting glimmer now and then of what it
would be like to be with some movie star or
a friend or a fellow passenger on the bus? If
those thoughts crop up in your head, you
can be sure they enter your partner's
thoughts as well. But if you both make the
effort to keep them as fleeting as possible,
then they really pose no danger, unless one
of you lets jealousy rear its ugly head and
blows it all out of proportion.

Anonymous

SUBMISSION

*Translated from the Siamese (Thai) by
E. Powys Mathers*

When you have bathed in the river
On the moon's third day,
You make yourself, ah, so the more to be desired
By slipping on a robe the color of your body.
Tell me, child, are three baskets of saffron enough
To color your breasts and your arms and your face?

No other girl knows, like you, how to entice me,
Walking alone in the shadows of the palm trees.
None has your tickling gestures, your enflaming eyes—
So young, so smooth, and so flower fresh,
You must have more men silly about you
Than there are corners in your bedroom to hide them.

In the morning when I come to see you under the
verandah
Just for the pleasure of talking to you;
Or in the evening when I curry favor with the poulterer
Just for the pleasure of feeling myself near you;
Or at night when my hand seeks to clasp you
Through the hole pierced in the planking by your bed;
Your mother can say all she likes,
Reproaches, insults, swear-words, I accept all in
advance.
But I conjure you do not refuse me
A quite small corner of your bedroom in which to hide.

THERE IS NO DENYING that Asian women have their own set of special powers over men. As a Western woman I most definitely would not want to walk three steps behind my husband, as the traditional Japanese wife always did, but on the other hand, I know that it was the geisha who had the upper hand, not her customer.

Whether or not a Western woman feels that she could live the lifestyle of an Asian woman on a permanent basis, an evening where she pretended to do so might be an exciting one for both her and her partner. Play-acting is not a commitment. If one partner acts submissive one time, they can switch roles the next. The real enemy to a relationship is boredom and if donning a kimono and serving tea and otherwise submitting to your partner's desires can keep boredom at bay, then even the most feminist woman will find it a sacrifice well worth making.

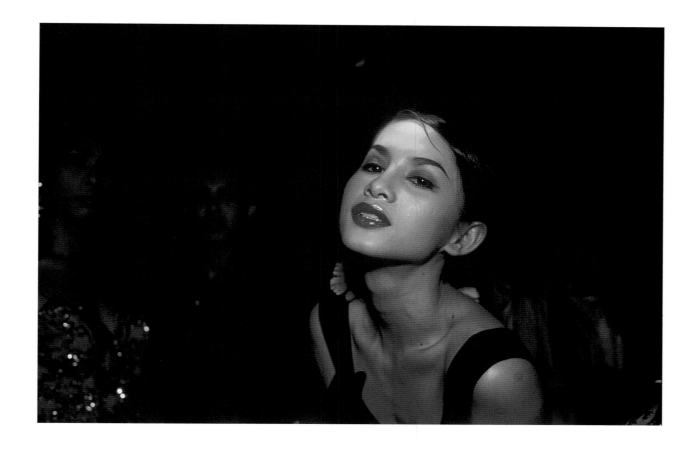

Nan Goldin (b. 1953). **C in the Club Bangkok.** 1992. Cibachrome print. 121

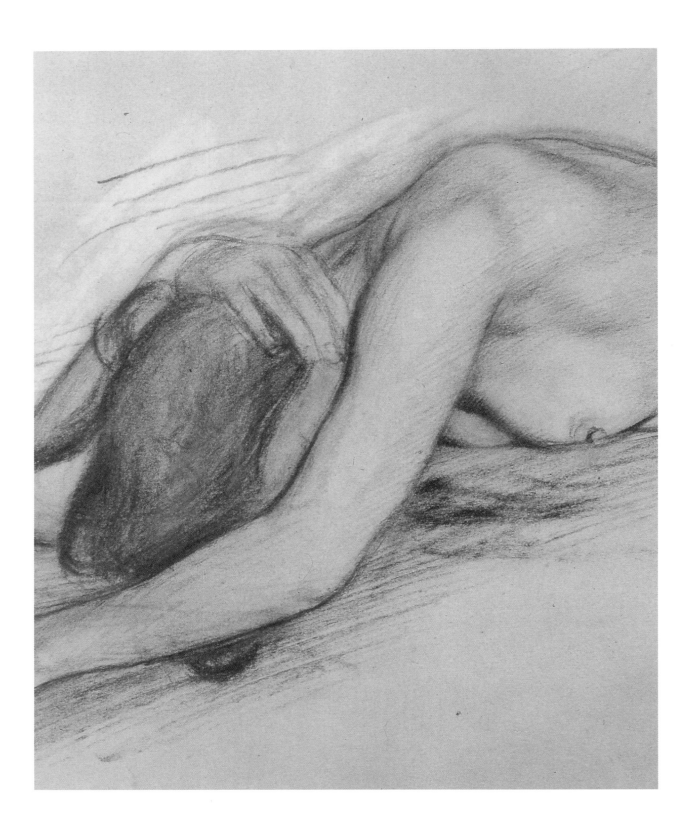

you're not with me

BEING ALONE AND BEING LONELY are distinctly different experiences. A person can become accustomed to being alone, and some prefer it. But loneliness is a kind of heartache, often due to the absence of one special "other." Less is known about the psychology of these absent objects of affection. Do they know that they are missed, do they care, do they enjoy it? And if so, why?

Anna Akhmatova (1889–1966)

I SEE, I SEE THE CRESCENT MOON
Translated from the Russian by Richard McKane

I see, I see the crescent moon
through the willow's thick foliage.
I hear, I hear the regular beat
of unshod hooves.

You don't want to sleep either?
In a year you weren't able to forget me,
you're not used to finding
your bed empty?

Don't I talk with you
in the sharp cries of falcons?
Don't I look into your eyes
from the matte, white pages?

Why do you circle round
the silent house like a thief?
Or do you remember the agreement
and wait for me alive?

I am falling asleep. The moon's blade
cuts through the stilling dark.
Again hoofbeats. It is my own warm
heart that beats so.

AT WHAT POINT do those hooves in your heart stop? And is it possible to ever get them going again? Lovers marry and the years go by and the strong feelings that they both had in the beginning start to fade. Perhaps fade isn't the right word, because in many cases they don't disappear but are transformed into a less frantic, less passionate kind of love. But don't we all miss those hooves, not to mention those butterflies in our stomachs and the sweaty palms and even the aches that came when we were forced to separate?

It's the difference between a fire made of dry wood and one where charcoal is the fuel. The dry wood will burn brightly but will soon burn itself out. That's why you want to put some charcoal on top of those twigs, so the fire will burn all night long.

Two people probably couldn't survive those bright flames endlessly or they would be consumed, but even if the memory of those flames is practically gone, it can still send a chill down the spine of any relationship. So as often as possible make an effort to rekindle that romance of yours. Go out for dinner. Buy each other little presents. Hold hands as you walk down the street. Say, "I love you." You may not be able to create a conflagration, but just as when you blow on charcoal to make it glow brightly, your efforts will have an effect.

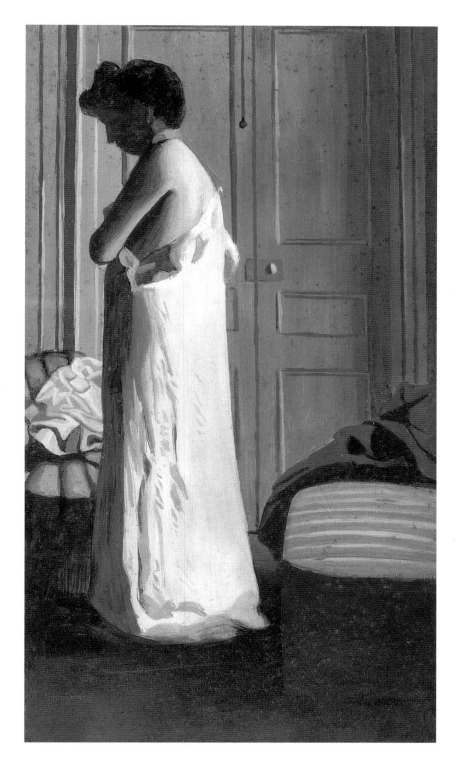

Félix Vallotton (1865–1925). **Woman Removing Her Chemise.** 1900. Oil on board.

125

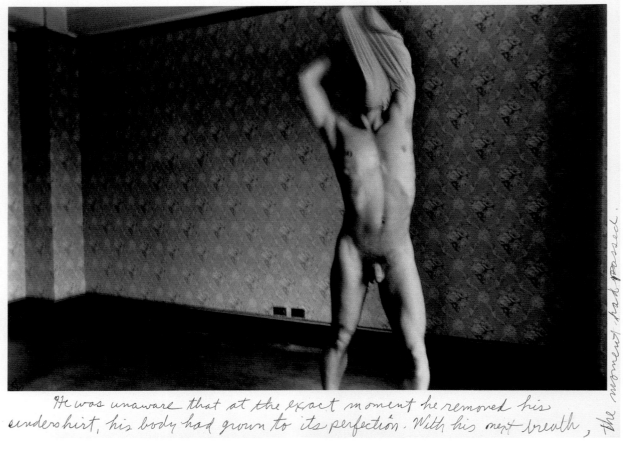

He was unaware that at the exact moment he removed his undershirt, his body had grown to its perfection. With his next breath, the moment had passed.

Duane Michals (b. 1932). **He was unaware that at the exact moment...** (from *Homage to Cavafy*). 1978. Gelatin-silver print.

C. P. Cavafy (1863–1933)

RETURN

Translated from the Greek by John Mavrogordato

Return often and take me,
Beloved sensation, return and take me—
When the body's memory awakens,
And old desire resurges in the blood;
When the lips and the skin remember,
And the hands feel as if they are touching again.

Return often and take me in the night,
When the lips and the skin remember . . .

FOR SOME PEOPLE the path of love is never smooth because they devote their energies to seeking out each and every bump, while others have a very smooth way because they remain in the same groove and avoid any irregularities.

It may be tempting to say the latter have it better than the former, but in matters of love, things are not always so simple. It may make sense that someone who is constantly rejected would want to change his ways, but if he or she has not found satisfaction in relationships where both parties love each other equally, then that which seems reasonable may not make sense for that person. It is not for us to pressure people to change to match our sensibilities. It is best to live and let live. The differences among people also make life more interesting and more entertaining.

Christina Rossetti (1830-1894)

COME BACK TO ME

Sonnet I from Monna Innominata

Come back to me, who wait and watch for you—
 Or come not yet, for it is over then,
 And long it is before you come again,
So far between my pleasures are and few.
While, when you come not, what I do I do
 Thinking 'Now when he comes,' my sweetest 'when':
 For one man is my world of all the men
This wide world holds; O love, my world is you.
Howbeit, to meet you grows almost a pang
 Because the pang of parting comes so soon;
 My hope hangs waning, waxing, like a moon
 Between the heavenly days on which we meet:
Ah me, but where are now the songs I sang
 When life was sweet because you called them sweet?

THE MESSAGE BEHIND this poem and painting is that some women get their man and some women never do. The ones who are in the worst straits are those women having an affair with a married man. Once they've put themselves into one of these situations, it is very difficult to get back out. They've allowed themselves to fall in love and as long as they get the occasional bone thrown their way, they're willing to sit home waiting for the next one. That's not to say that there aren't some men who get themselves in similar predicaments, but it's more often than not a woman who accepts such one-sided conditions.

This sort of relationship wouldn't be so bad if it were based on reality. If it was a situation where the woman didn't want to have a man around her all the time because she treasured her independence, and found seeing some married man occasionally to be the ideal type of relationship for her, then all would be well. But it always seems that these women are just waiting for their married lover to get that oft-promised divorce, a divorce that probably will never come, or even if it should come, may not change their status much at all.

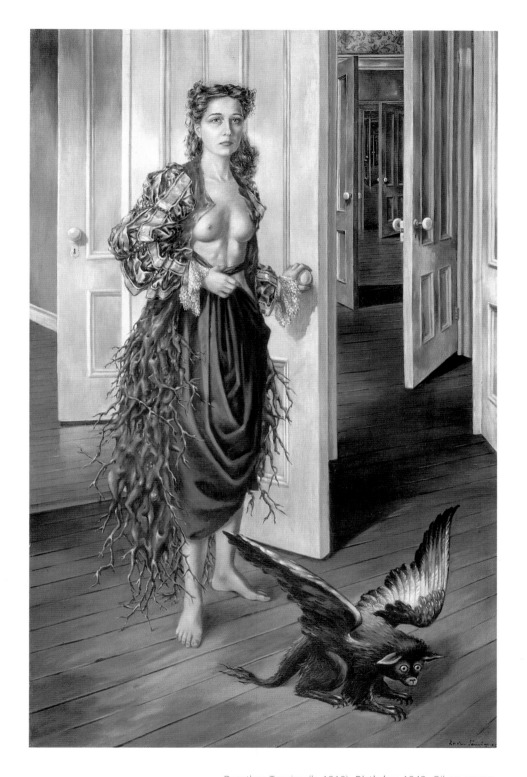

Dorothea Tanning (b. 1910). **Birthday.** 1942. Oil on canvas. 129

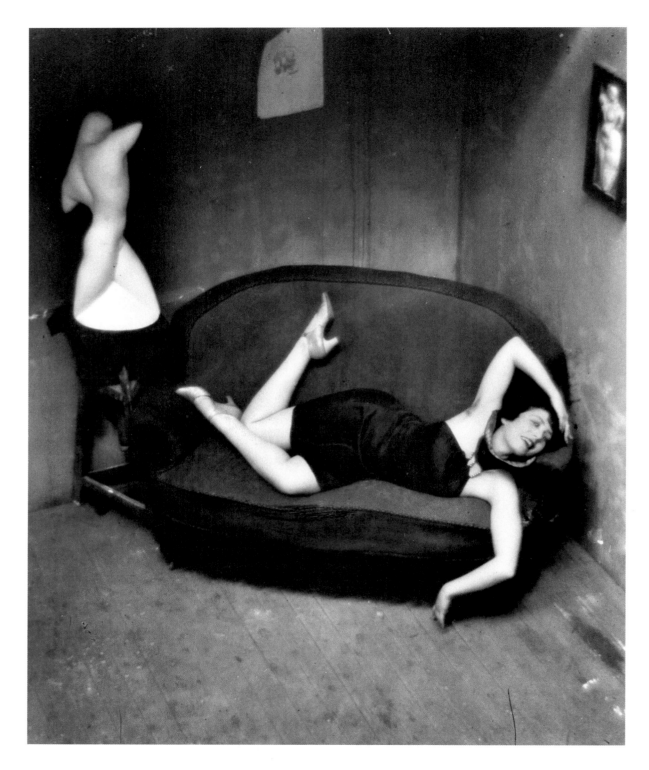

130 André Kertész (1894–1985). **Satyric Dancer.** Paris. 1926. Gelatin-silver print.

Sandra M. Gilbert (b. 1936)
THE LOVE SICKNESS

You lie on the sofa all day, washed in fog,
your heart twittering like a thrush among prickly
branches.
You think you're that last black tree before the beach,
the one
that trembles so close to the cliff edge it seems to have
one toe in the abyss. . .

Your toes are dissolving like that, your whole body
melting and thinning, becoming transparent, becom-
ing
the room, the sofa, the fog, the twittering inside.

It's the love sickness! It's the damned old nausea
of desire, the ague that shakes the last right angle
of reason from your bones
and turns the world to stupid
metaphors for passion.

You peer through the fog like a nearsighted hiker
on a stony seaside path.
Your toes and knees are gone, and the rest of you
dissolving fast: soon you'll be nothing
but the buzz of love, the ache, the fever.

And now, out there, where a window once was,
you think you see the face of the one you love!
It shines toward you like a tiny moon
on a misty night, or a lucky penny,
or a pale expensive sugar candy.

HERE'S A QUESTION to pose yourself: Would it be better if love always glided down some downy surface, or does the bumpy road that those in love so often find themselves on improve the quality of the final, marvelous destination? I'm the first one to admit that I don't have a definitive answer. In my practice, I certainly see those who suffer because of love and I know the pain it can bring. But when things come too easily to us, we often don't appreciate them. It would be great if there could be some middle road, but I've yet to find the map where it is marked.

So that leaves too many people having to muddle through, in love yet not entirely satisfied. It's sad, but perhaps because of the sadness we do enjoy the happiness all that more. Perhaps.

Anne Sexton (1928–1974)

THE BALLAD OF THE LONELY MASTURBATOR

The end of the affair is always death.
She's my workshop. Slippery eye,
out of the tribe of myself my breath
finds you gone. I horrify
those who stand by. I am fed.
At night, alone, I marry the bed.

Finger to finger, now she's mine.
She's not too far. She's my encounter.
I beat her like a bell. I recline
in the bower where you used to mount her.
Your borrowed me on the flowered spread.
At night, alone, I marry the bed.

Take for instance this night, my love,
that every single couple puts together
with a joint overturning, beneath, above,
the abundant two on sponge and feather,
kneeling and pushing, head to head.
At night alone, I marry the bed.

I break out of my body this way,
an annoying miracle. Could I
put the dream market on display?
I am spread out. I crucify.
My little plum is what you said.
At night, alone, I marry the bed.

Then my black-eyed rival came.
The lady of water, rising on the beach,
a piano at her fingertips, shame
on her lips and a flute's speech.
And I was the knock-kneed broom instead.
At night, alone, I marry the bed.

She took you the way a woman takes
a bargain dress off the rack
and I broke the way a stone breaks.
I give back your books and fishing tack.

Today's paper says that you are wed.
At night, alone, I marry the bed.

The boys and girls are one tonight.
They unbutton blouses. They unzip flies.
They take off shoes. The turn off the light.
The glimmering creatures are full of lies.
They are eating each other. They are overfed.
At night, alone, I marry the bed.

I KNOW THAT MANY PEOPLE who masturbate are lonely. They don't have a partner, or they've just lost a partner as in this poem, and so they seek solace by pleasuring themselves. There's nothing wrong with that, as long as masturbation doesn't take over their lives. People who masturbate instead of going to work or studying for school or seeing friends are making a big mistake.

But masturbation isn't just for those people who don't have a partner. A couple is not a set of Siamese twins. One partner may feel the need to have sexual satisfaction more often than his or her partner, and masturbating can help them avoid feeling sexually frustrated. As long as the one partner isn't masturbating instead of having sex with his partner, but only doing it in addition, then it shouldn't cause any difficulties. Of course, the person masturbating needn't advertise these activities to the other, as that might just cause needless conflict. The one danger that masturbation can pose to a relationship is if one partner begins to prefer masturbation to having sex. Some people do find that masturbation is more satisfying, or get hooked on the erotic material that they use to arouse themselves. But if masturbation can be controlled, it needn't harm a relationship, and can even act as a positive force by alleviating damaging sexual frustrations.

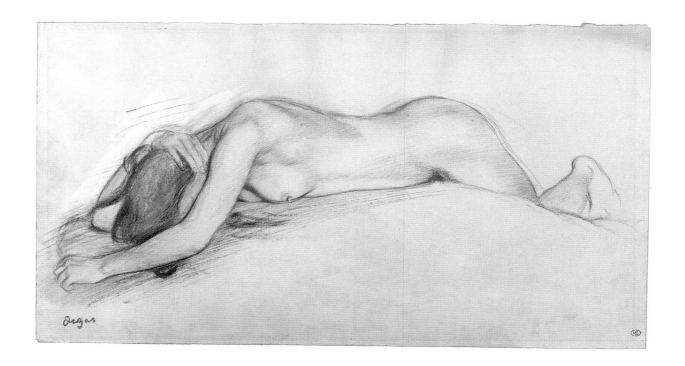

Edgar Degas (1834–1917). **Nude Lying Face Down.** c. 1863–65. Pencil. 133

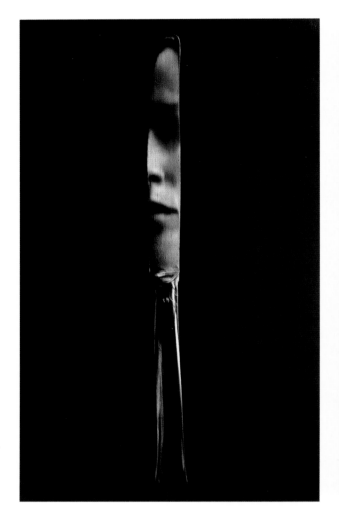

134 Alain Fleischer (b. 1944). **L'âme du couteau (The Knife)** and **Le dos de la cuiller (The Spoon)**. 1985. Salt print photographs.

Alison Fell (b. 1944)

SUPPER

There is the curdling sky
and the green spry beans
finger-long and knuckled
and the bird's flat fleeting path
across my window
and still
you will not come

THESE IMAGES BY FLEISCHER remind me of the traditional view of someone looking through a keyhole. The person being looked at is often someone who is unobtainable, as is the person who will not come in Fell's poem.

There's nothing you can do to prevent yourself from falling in love with someone who doesn't love you back. After all, it's not until you try that you'll know whether they'll accept or reject your appeal. But while you're waiting for a response, it's quite possible for your feelings to grow into a one-sided love. If you can't then fall out of love should the loved one reject you, and you spend weeks, months, even years pining after someone who is not interested, then you have a serious problem. Your time on this earth is too fleeting and too precious to waste this way. There comes a time when you must seal those emotions up and move on with your life. The object of your affection cannot or will not reciprocate your feelings, and so you must accept this for what it is and start searching for someone who will let you in through the keyhole.

Sappho (6th Century B.C.E.)

BE KIND TO ME
Translated from the Greek by Mary Barnard

Gongyla, I ask only
that you wear the cream
white dress when you come

Desire darts about your
loveliness, drawn down in
circling flight at sight of it

and I am glad, although
once I too quarrelled
with Aphrodite

to whom
I pray that you will
come soon

IT'S TOO BAD that we use the word "love" so broadly. We love ice cream. We love our children. We love our spouse. We make love. In fact, the emotion you feel toward one person may have several different shades during the course of the same day. For example, the emotion you feel toward your lover in the morning as she's sleeping on her pillow may be quite different from what you felt the night before when your bodies were connected. We need new words to express these entirely different emotions.

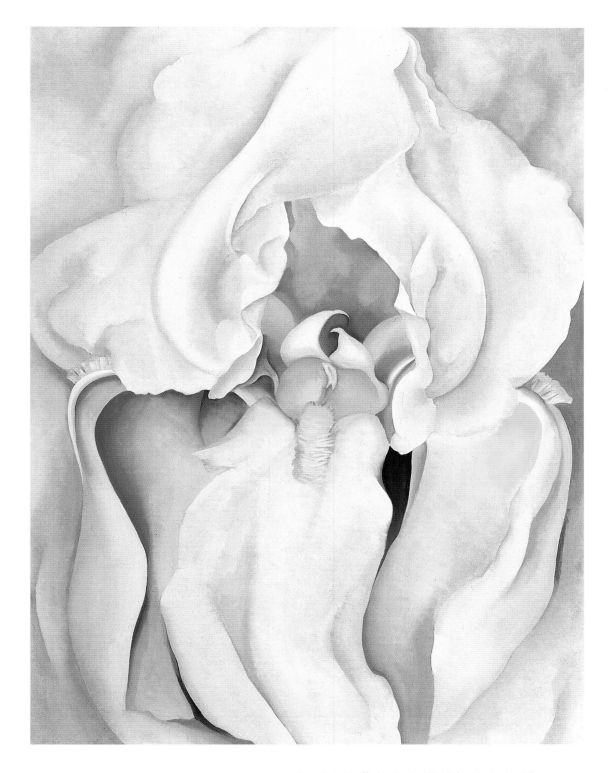

Georgia O'Keeffe (1887–1986). **Light Iris.** 1924. Oil on canvas. 137

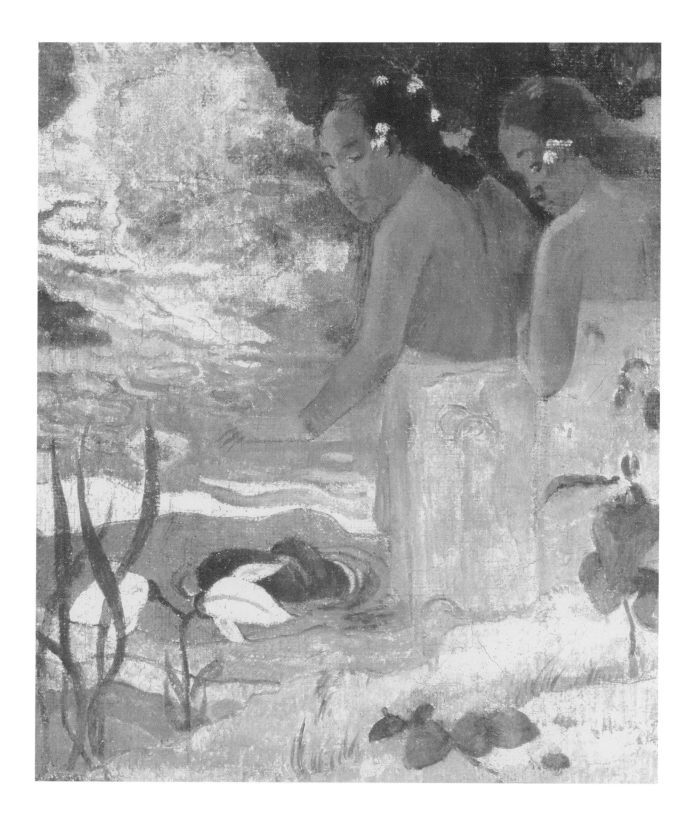

enduring Love

THERE IS NO MAGIC FORMULA TO MAKE LOVE LAST. We can identify some of the ingredients, however. As to the other person, a sense of freshness is important; we don't become tired of their looks, their ways; they seem new to us even as they become increasingly dear and familiar. As to ourselves, whatever we can do to remain fresh and pleasing to our lover, we should try it.

Lady Heguri (8th Century)

A THOUSAND YEARS, YOU SAID

Translated from the Japanese by
Geoffrey Bownas and Anthony Thwaite

A thousand years, you said,
as our hearts melted.
I look at the hand you held,
and the ache is hard to bear.

EVEN A LITTLE POEM can pack quite a wallop. Of course those who have never suffered from a broken heart can't know the depths of those words. But, sadly, those people are few and far between because over the course of a lifetime it seems that most individuals have suffered the angst of at least one breakup.

Most people who suffer heartbreak move on with their lives. Most even fall in love again. But you never forget those romances that end badly. Every once in a while, after years or even decades, something reminds you of that person and you feel a little twinge of pain. You might even have felt it reading this poem.

Another experience you might never forget is a threesome as depicted in this Japanese print. However, because such combinations often result in jealousy and heart break, you might be better off leaving such experiences to the world of fantasy.

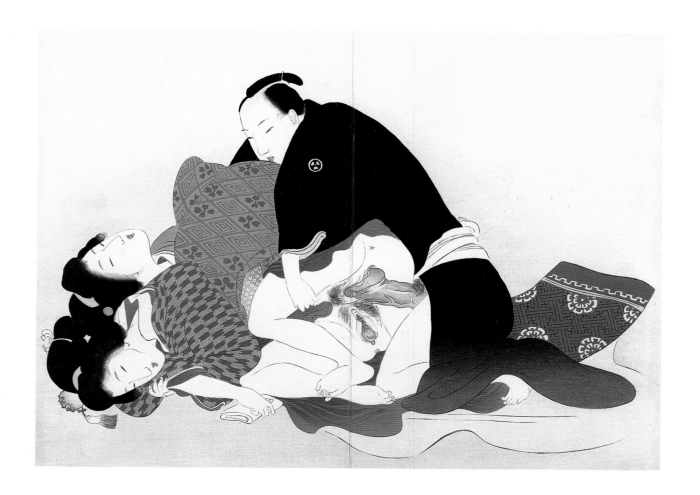

Japanese (19th Century). **Ménage à Trois.** Meiji Period, c. 1890. Color wood block. 141

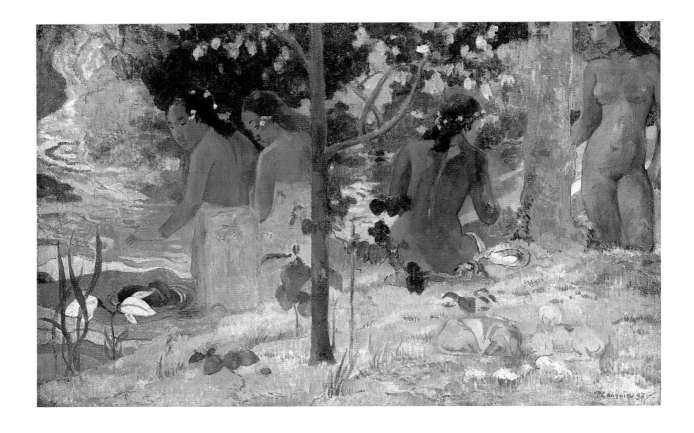

Paul Gauguin (1848–1903). **The Bathers.** 1897. Oil on canvas.

John Ciardi (1916–1986)

THAT SUMMER'S SHORE

On the Island, finding you naked and pearled
in a summer sea, and our daughter naked by you,
at froth with the universe and laughing a splendor
into the huff and sneeze-out of the swell—

finding you there, you two, by that most world
most spoken, saying from time
how we are inhaled and exhaled by a sound
between two water-heaves, I swore

to speak the deeps of the kiss of man and woman,
to say you as you are inside my breath
after the turning apart of arms from their twining,
in the night nest before sleep, yet truer than waking,

warm from your warmth, this man beside this woman,
all man beside all woman, at touch and Adamic.
I speak that nearness in the tongue of prayer,
seeing you distanced by the sea that distances all,

yet naked as all touch of human nights
housed in their candle-breath above the huff,
my hand shaped into sleep across your hand
as anything in nature seeks its resting.

So, returning from the Mainland, I found you
there in the sea in your woman nakedness,
and the girl in her girl nakedness, and the sea
silken and long and breathing of our sleep.

Thigh-deep in water, you stood and waved,
the woman-pear of your body drawn full
to the left of your arm, and your breasts
flecked with prisms, and your fur with crystals.

And there at the lace-edge, ankle-splash-deep, the girl
ran chittering in her bud-roundness. She
was all peach and you were pear-and-almond,
your roundness slackened but sweeter for ripeness.

And in joy and in terror, I saw the sea
blink, and you were not there, and I was not there,
and the round girl had slackened to woman, and
another
round girl ran chittering by the sea and was watched
in love.

And I made this praise to your nakedness in the sea.

HOW RARE IT IS that we are bare naked. Not naked
in the shower or under the covers or at home with
the blinds closed, but naked out in the sun. I bet
most people haven't even come close to such a situ-
ation since they were little children. I think we'd all
be happier if we could shed our prudery, but I
know it's not that easily done. But you might want
to take at least one opportunity to strip off your
garments and be one with nature.

Gwendolyn Brooks (1917–2000)

BLACK LOVE

Black love, provide the adequate electric
for what is lapsed and lenient in us now.

Rouse us from blur. Call us.

Call adequately the postponed corner brother.
And call our man in the pin-stripe suiting and restore
him to his abler logic; to his people.

Call to the shattered sister and repair her
in her difficult hour, narrow her fever.

Call to the Elders—
our customary grace and further sun
loved in the Long-Ago, loathed in the Lately;
a luxury of languish and of rust.

Appraise, assess our Workers in the Wild, lest they
descend to malformation and to undertow.

Black love, define and escort our young, be means and
 redemption, discipline.

Nourish our children—proud, strong
little men upright-easy:
quick
flexed
little stern-warm historywomen . . .
I see them in Ghana, Kenya, in the city of Dar-es-
 Salam, in Kalamazoo, Mound Bayou, in Chicago.

Lovely loving children
with long soft eyes.

Black love, prepare us all for interruptions;
assaults, unwanted pauses; furnish for leavings and
 for losses.

Just come out Blackly glowing!

On the ledges—in the lattices—against the failing
 light of
candles that stutter,
and in the chop and challenge of our apprehension—
be
the Always wonderful of this world.

THERE'S THAT OLD SAYING, "Love conquers all," but it's not true. If your partner is dying of cancer, all the love in the world won't spare him or her from the disease. But what is true is that love can survive and flourish even amidst all sorts of horrors. And while it is not a cure-all, it can bring enormous relief and strength.

Black people in America have needed love more than most groups, as so much hate has been directed their way. Yet when slave families were torn apart, their very love for one another was used against them. Such a history will also color the present, even if two hundred years have passed. But whether or not love can conquer all, it's most definitely a universal emotion that transcends all color barriers.

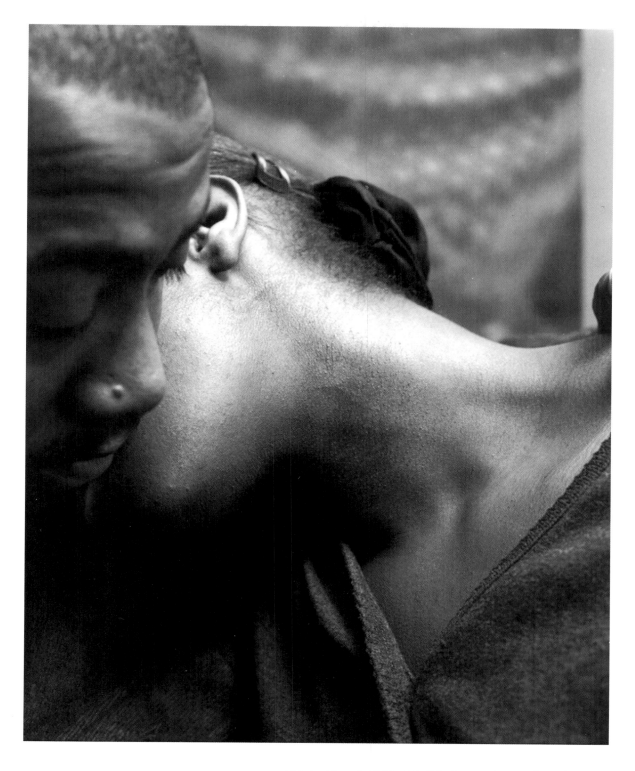

Nicholas Nixon (b. 1947). **C.C., R.S., Boston.** 2000. Gelatin-silver print. 145

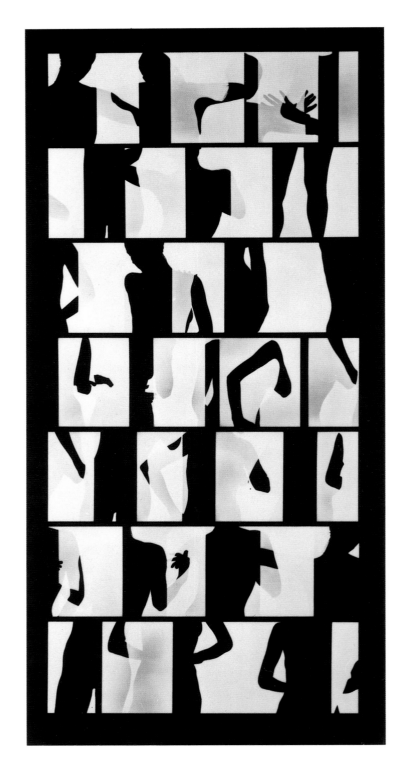

Ray K. Metzker (b. 1931). **Nude Composite.** 1966–90. Gelatin-silver print.

Ilyas Abu Shabaka (1903–1947)

YOU OR I?

Translated from the Arabic by
Adnan Haydar and Michael Beard

This beauty, is it yours or is it mine?
In you I see a person beautiful in love
Like me. And which of us has given me life?
Is it your shape or mine that I love so?
When in my dream I see love's images
Is it your shadow in my soul or mine?
Love, all of love, dwells in all I see.
Whence all this light? Your universal soul?

Did I create you in the world of fancy
Or are you my creator?
Am I the first whom inspiration blessed
Or was it you? Who writes this verse?
Did I write it for you or you for me?
And who in love can be dictated to
And who dictates? Our imaginations blend,
Your soul within my soul, your mind in mine.
When things appear obscure to me I see
A doubting shadow dawning in your eyes
When we met first I found my beginning
As if you were a lost part of my being.

YOU CAN LOVE SOMEONE from afar, but that feeling does not approach the feeling experienced by two people who fall in love with each other. Love may not have any apparent physical form, and yet it reacts when a lover meets a mate. Love is one of those natural forces that you can't see, like gravity, but which has a very real effect. Gravity keeps you from floating off into space, but love can defy gravity and leave you floating on air.

In physics, when two molecules come together, they exchange tiny little particles with names like muons and quarks. I propose that when two people fall in love, they exchange love "particles" which I would label "lovons." Scientists may not have identified these particles yet, but the effects are clearly there, as anyone who has been in love can attest.

Sadly, these lovons don't always maintain their stickiness and thus lose their effect, and the lovers can separate and become single entities again. But even if this occurs, the two former lovers are never quite the same. Some of the lovons still cling to them in the form of memories and feelings and so these lovons will always have some influence on them. Of course anyone who's taken my course, "Physics for Lovers," already knows all of this.

Pablo Neruda (1904-1973)

MATERIA NUPCIAL

Translated from the Spanish by Clayton Eshleman

Trunk of cherry-tree without bark or flowers
particular, ignited, with veins, saliva
testicles and fingers
I watched a girl of paper and moon
horizontal, trembling, breathing and
 white
nipples like two separate codes,
rosebush uniting her thighs
 where her
sex of eyelids nightly blinks

I'm pallid I boil over
words ruin in my mouth
words like drowned children
and sailing sailing teeth growing ships
waters, latitude like charred forests—

I'll arrange her a sword or a mirror
open her timid legs till I die
bite her ears, veins
till she draws back with closed eyes I'll
dance in a canal of green semen,

flood her with poppies and lightning
truss her in knees in lips in needles
open her inch by inch with weeping epidermis
with thug pressure, with soaked hair,

make her flee escaping fingernails, sighs
toward never toward *nada*
fighting up to the heavy marrow to oxygen
seizing memory, cause,
like a lone hand, a severed finger
agitating a nail of deserted salt.

She must run sleeping down roads of skin
in a country of ash-colored gum and cinders,
fighting with knives sheets ants
with eyes falling in her like deaths,
drops of black slippery matter,
blind fish or balls of dense water.

I AM OFTEN ASKED if people from different parts of the world have different thoughts about sex. The truth is that the questions I am asked tend to be the same, but various cultures certainly have distinct sexual stereotypes: Americans are generally described as puritanical, Latins are said to be passionate, and so forth. Someone who expresses a great deal of emotion is certainly more likely to have an explosive love life than the strong, silent type. When emotions are bottled up and not communicated to one's partner, the relationship begins to suffer.

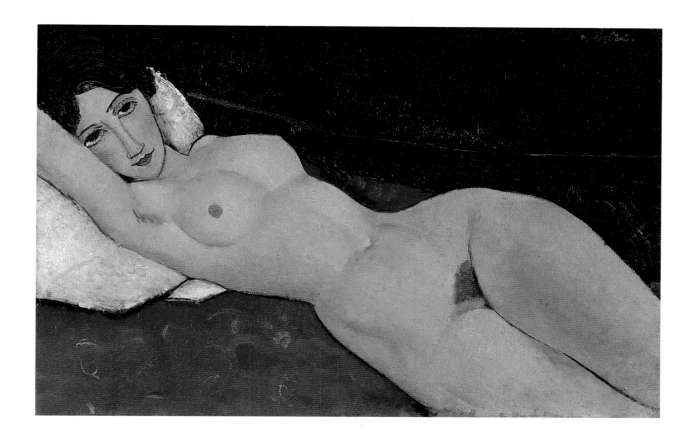

Amadeo Modigliani (1884–1920). **Nude Reclining on a Cushion.** 1917. Oil on canvas.

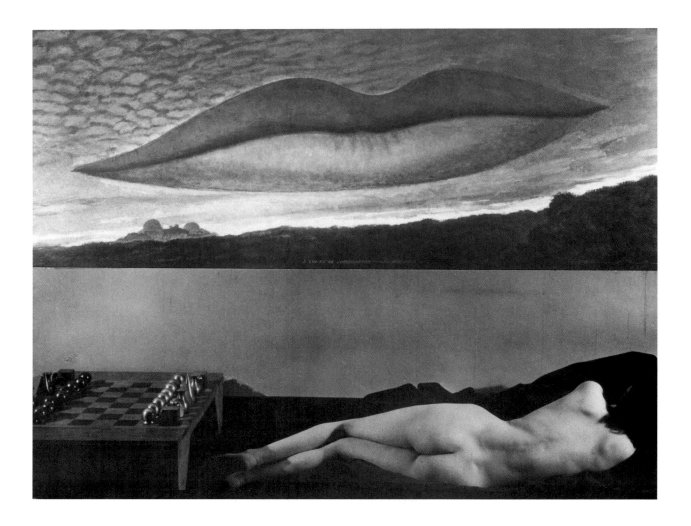

Man Ray (1890–1977). **Untitled.** 1934. Gelatin-silver print.

Mary Ann Larkin (b. 1945)

KEEPING TIME

Here I sit in the bowl of the world
someone's finger on the Pole Star
spinning me, gravely,
watching me watching them.
My guy's asleep in the loft upstairs,
home from the city.
He wants to still his mind, he told me.
The sun's arcing lower now.
It's 7 a.m. in September.
I watch the stars after dark
and never get lonely.
Saturdays I cut strawberries
and wash blueberries
for buckwheat pancakes.
Under the stove, a cricket's
keeping time. Last night
I saw Deneb in the tail of the Swan,
and I noticed too, when my guy came back,
how I kept swallowing my saliva,
just like the Tao master says
a woman does
when she's ready for her man
to come into her.

WHEN WE LOOK UP into the night sky there's a tendency to feel small. Within our four walls everything is built to our scale, but when we look up knowing that there are billions of stars out there, the vastness of the numbers and the distances can make us feel puny.

But as someone who is only 4'7", my suggestion is not to dwell on such thoughts. You can be as powerful as you want to be. You have powers not shared by all those stars and galaxies, not the least of which is to feel pleasure. Size is a factor but it does not control your life. So, if looking up at the heavens makes you feel small, then simply don't. Or move to a big city where the millions of lights created by humans are so blinding that you can't see the stars and you can go around thinking of yourself as a master of the universe.

John Holmes (1904–1962)

THE FLOWER

The sun was gold over the water and the voices golden,
 Air was all summer in one hour, and none
Among us at the foot of the old wall with vine laden
 But loved each other and would not be gone,

Nor let this life in the hot sun cool to evening,
 Or care, or cross our shadows, or speak much.
Fragrant and still and slow, the garden murmured
 And we flowered with it like gold blossoms to touch

That no one would gather all and carry away, silence
 In no motion whirling us all together like light,
And the light going, and the sweetness more, and only
 You there that would be shining in the night,

You only that always of that garden would be summer,
 And day was nothing, the names of faces, the hour
Nothing that was not you, not the water or voices,
 Nor the air the sun warmed to open the flower.

I crossed the garden, going a little away from them all,
 To take for you, to take the moment, take you
And the green gold summering garden forever and ever
 And the water, and shadows where sun came through.

But bringing it back, great in my hands and heavy
 With itself and time, thinking no one saw under the tree
This flower for you, I looked up, and there in sunlight
 You were running, running, with a flower for me.

I'M NOT MUCH IN FAVOR of broad statements, yet I think it's safe to say that there's not enough passion in the world. It's safer to be cool. Why risk falling in love to have sex when you can satisfy your lust in a one-night stand? Why get absorbed in a novel if you can channel surf? Why cook a gourmet meal when there's fast food? Why bother voting, no less protesting?

Maybe it's because we're bombarded with stimuli that when we get the chance, so many of us prefer to retreat into a cocoon. Of course, many people do join in forming a couple, but you get the sense that their twoness is not what is most important. If things aren't working out quite right, there's not much hesitation to abandon the relationship, and that's partly because the two parties haven't invested themselves in each other all that much.

Passion can be a dangerous thing. Fanatics have made us paranoid about flying or opening a package or visiting certain parts of the world. But society needs a degree of passion in order to push forward. Be it in science or art or politics, to break new ground requires someone who is willing to go the extra mile, maybe looking foolish while doing so. But if children grow up in a world where passion is looked down upon, their innate passion can be squelched. So set a good example and give in to passion. Don't be afraid of going overboard. No matter what those around you say, let yourself go to extremes. Not all the time. Not about everything. But if you start to feel the urge, don't squelch it, go for it.

Joan Miró (1893–1983). **Dawn Perfumed by a Shower of Gold.** 1954. Watercolor and plaster on composition board.

Marc Chagall (1887–1985). **Nude and Vase of Flowers.** 1953–56. Watercolor and mixed media on paper.

I AM THE ROSE OF SHARON

I am the rose of Sharon,
 and the lily of the valleys.
As the lily among thorns,
so is my love among the daughters.
As the apple tree among the trees of the wood,
 so is my beloved among the sons.
 I sat down under his shadow with great delight,
 and his fruit was sweet to my taste.
He brought me to the banqueting house,
 and his banner over me was love.
Stay me with flagons,
 comfort me with apples:
 for I am sick of love.
His left hand is under my head,
 and his right hand doth embrace me.
I charge you, O ye daughters of Jerusalem,
 by the roes and by the hinds of the field,
 that ye stir not up, nor awake my love,
 till he please.
The voice of my beloved!
 Behold, he cometh
 leaping upon the mountains,
 skipping upon the hills.
My beloved is like a roe or a young hart:
 behold, he standeth behind our wall,
 he looketh forth at the windows,
 shewing himself through the lattice.
My beloved spake, and said unto me,
 Rise up, my love, my fair one, and come away.
For lo, the winter is past,
 the rain is over and gone;
the flowers appear on the earth;
 the time of the singing of birds is come,
 and the voice of the turtle is heard in our land;
the fig tree putteth forth her green figs,
 and the vines with the tender grape give a good smell.
 Arise, my love, my fair one, and come away.

O my dove, that art in the clefts of the rock,
 in the secret places of the stairs,
 let me see thy countenance,
 let me hear thy voice;
 for sweet is thy voice,
 and thy countenance is comely.
Take us the foxes, the little foxes, that spoil the vines:
 for our vines have tender grapes.
My beloved is mine, and I am his:
 he feedeth among the lilies.
Until the day break, and the shadows flee away,
 turn, my beloved,
 and be thou like a roe or a young hart
 upon the mountains of Bether.

THE WISE JEWISH KING Solomon supposedly wrote 1,005 songs, and only one, the Song of Solomon (of which this is an excerpt), survives. While it is obviously about the love of a man and a woman, it has also been considered to be about the love of God and his people. Some believers have thrown a shroud over the love shared between men and women, and especially over its complement, sex. Of course, other human appetites, such as those for wine and good food and even art itself have also been so banished by some. To such people, belief in God requires pushing aside our own humanity. But if God passed our human traits to us, then rather than shunt them aside shouldn't they be front and center? I think you know where I stand on this issue. If you have never given thought to it, I suggest that you do and decide for yourself whether you are giving your sexual self its proper due. Yes, under certain circumstances sex can be abused so that it is dirty and something of which to be ashamed, but with a little care, it can be as glorious as any other of God's gifts.

text credits

art credits

p. 11: courtesy Galerie Claude Bernard. © 2002 Artists Rights Society (ARS), New York / ADAGP, Paris; p. 12: The Museum of Modern Art, New York. Acquired through the Lillie P. Bliss Bequest. Photograph © 2002 The Museum of Modern Art, New York. © 2002 Artists Rights Society (ARS), New York / ADAGP, Paris; p. 15: The Norton Simon Foundation, Pasadena, CA; p. 16: © Estate of Roy Lichtenstein. Photo courtesy Museum fur Moderne Kunst, Frankfurt am Main, Ehemalige Sammlung Stroher, Darmstadt. Photo by Rudolf Nagel; p. 19: The Museum of Modern Art, New York. Gift of John Hay Whitney. Photograph © 2002 The Museum of Modren Art, New York; p. 20: © Marcel Broodthaers, "Watchtower". Scottish National Gallery of Modern Art, Edinburgh. Photograph by Antonia Reeve. © 2002 Artists Rights Society (ARS), New York / SABAM, Brussels; p. 23: © 2002 Picasso Administration / Artists Rights Society (ARS), New York. Photo RMN: Michele Bellot, Reunion des Musees Nationaux/Art Resource, NY, Musee Picasso; p. 27: Hirshhorn Museum and Sculpture Garden, Smithsonian Institution, Gift of Joseph H. Hirshhorn Foundation, 1966, Photograph by Lee Stalsworth. © 2002 Artists Rights Society (ARS), New York / ADAGP, Paris, France; p. 28: © Courtesy of The Artists Estate, The National Gallery of Ireland; p. 31: The Museum of Modern Art, New York. The William B. Jaffe and Evelyn A.J. Hall Collection. Photograph © 2002 The Museum of Modern Art, New York. © 2002

The Munch Museum / The Munch-Ellingsen Group / Artists Rights Society (ARS), New York; p. 32: © The Estate of Robert Mapplethorpe. Used with permission; p. 35: Fine Arts Museums of San Francisco, Anonymous gift to the California Palace of the Legion of Honor, 1940.104. © T.H. Benton and R.P. Benton, Testamentary Trusts / Licensed by VAGA, New York, NY; p. 36: © Erich Lessing / Art Resource, NY. Museo Archeologico Nazionale, Naples, Italy. ; p. 39: © Christo 1968. Photograph by Klaus Baum; p. 43: © 2002 Robert Morris / Artists Rights Society (ARS), New York; p. 44: © Erich Lessing / Art Resource, NY. Oesterreichische Galerie, Vienna, Austria; 47: © Tom Wesselmann / Licensed by VAGA, New York, NY; p. 48: ©2002 Picasso Administration / Artist Rights Society (ARS), New York; p. 51: © Smithsonian American Art Museum, Washington, D.C. / Art Resource, NY. © 2002 Man Ray Trust / Artists Rights Society (ARS), NY / ADAGP Paris; p. 52: © Reunion des Musees Nationaux/Art Resource, NY. Photograph by Herve Lewandowski. Louvre, Paris; p. 55: Private Collection - Photograph courtesy of The Lefevre Gallery (Alex Reid & Lefevre Ltd.), London; p. 56: © Werner Forman / Art Resource, NY. Collection Philip Goldman, London, Great Britain; p. 61: © Scala / Art Resource, NY. Pushkin Museum of Fine Arts, Moscow, Russia; p. 62: © Tono Stano; p. 65: © Jeff Koons; p. 66: © David Hockney; p. 69: © Erich Lessing / Art Resource, NY. Private collection, Paris, France. © 2002 Artists

Rights Society (ARS), New York / ADAGP, Paris; p. 70: © Salvador Dali Demart Pro Arte B.V., 2002. © Photo DESCHARNES / daliphoto.com. © 2002 Salvador Dali, Gala-Salvador Dali Foundation / Artists Rights Society (ARS), New York / VEGAP, Madrid; p. 73: ©Erich Lessing / Art Resource, NY. Musee du Petit Palais, Paris, France; p. 77: Norton Simon Museum, Pasadena, CA; p. 78: Courtesy the artist, Cindy Sherman and Metro Pictures, NY; p. 81: © 2002 Picasso Administration / Artist Rights Society (ARS), New York. Norton Simon Art Foundation, Pasadena, CA; p. 82: © Gottfried Helnwein. © 2002 Artist Rights Society (ARS), New York / VG Bild-Kunst, Bonn; p. 85: Private Collection © 2002 Succession Klein, Artists Rights Society (ARS), New York / ADAGP, Paris, France; p. 86: San Francisco Museum of Modern Art, Gift of Alfred E. Heller. Photograph by Ben Blackwell; p. 89: Norton Simon Art Foundation, Pasadena, CA. © 2002 Artists Rights Society (ARS), New York / ADAGP, Paris; p. 93: © New Bedford Whaling Museum; p. 94: © Erich Lessing / Art Resource, NY. Musee d'Orsay. Photograph by Jean Schormans. © 2002 Artists Rights Society (ARS), New York / ADAGP, Paris; p. 97: © The National Gallery, London; p. 98: © R.B. Kitaj, Courtesy Marlborough Gallery, New York; p. 101: Private Collection. © Viola v. Alvensleben, Munich. Photograph by Retro R. Petrini, Zurich, Switzerland; p. 102: The Museum of Modern Art, New York. The Joan and Lester Avnet Collection. Photograph ©

index *of artists and poets*